0335 005187

1-20

The Open University

Humanities: A Foundation Course **Units 29 to 36**

Industrialisation and Culture

Units 33 and 34 ART AND INDUSTRY

Prepared by Aaron Scharf for the Arts Foundation Course Team

THE OPEN UNIVERSITY PRESS

The Open University Press Walton Hall Bletchley Bucks

First published 1971

Copyright © 1971 The Open University

All rights reserved. No part of this work may be reproduced in any form, by
mimeograph or any other means without permission in writing from the
publishers.

Designed by The Media Development Group of The Open University

Printed in Great Britain by
OXLEY PRESS LTD.
EDINBURGH AND LONDON

SBN 335 00518 7

Open University courses provide a method of study for independent learners through an
integrated teaching system, including textual material, radio and television programmes
and short residential courses. This text is one of a series that make up the correspondence
element of the Arts Foundation Course.

The Open University's courses represent a new system of university-level education.
Much of the teaching material is still in a developmental stage. Courses and course
materials are, therefore, kept continually under revision. It is intended to issue regular
updating notes as and when the need arises, and new editions will be brought out when
necessary.

Further information on Open University courses may be obtained from The Admissions
Office, The Open University, P.O. Box 48, Bletchley, Buckinghamshire.

UNIT 33

UNIT 34

INTRODUCTION

1 OVERALL OBJECTIVES

To examine the effects of industrialisation on design and architecture, and to some extent on the arts of painting, sculpture and print-making. To assess the character of Victorian taste. To evaluate the criticisms of the dissenters (the ideological 'machine wreckers').

2 MORE SPECIFIC AIMS

(a) To describe the ways in which the further mechanisation of earlier techniques, the new use of older materials, and the use of new materials, helped to determine the design of products for everyday use, and how design itself engendered the further exploitation of those materials and techniques. (b) To make clear the concern of contemporary critics with specific elements in Victorian design. (c) To attempt to demonstrate that the growing fears that art and design – life itself – were being corrupted by mechanisation, contributed to a heightened awareness of the value of Art and a greater insistence on its necessity.

I would like to thank my colleagues on the Foundation Course Team for their helpful suggestions. I am especially grateful to Tim Benton for his section, IRON, and for his many useful observations.

SYNOPSES OF BROADCASTS

3 TELEVISION AND RADIO

UNIT 33 (Television)

CAST IRON IN ARCHITECTURE

This programme is a case study of the decorative and functional properties of one of the new materials discussed in this Unit. I have not treated the subject from a specifically historical point of view, but tried rather to show you as much as possible of what remains of Victorian cast iron, and some earlier examples, with an indication of why I think them important and representative of the period. Cast iron has survived better than any of the other new materials discussed, although much was lost for scrap during the wars, and many important monuments are being pulled down yearly even now. If the programme arouses in you a curiosity to keep your eyes open for nineteenth-century cast iron, and think about it as design and as historical evidence, then it will have succeeded in its primary aim.

(T.B.)

UNIT 34 (Television)

THE NUDE IN VICTORIAN ART

Perhaps it is one of the features of Victorian art that artists were on the whole highly reluctant to tackle themes expressly related to the effects of industrialisation on society. There were in fact several important exceptions to this rule and one could well have made a programme on the reaction of Victorian artists, consciously or otherwise, to Victorian change.

But instead, I've tried to illustrate the relationship between Victorian art and society by analogy, by investigating how Victorian artists tried to get round the problem of nudity in art. Society revealed its horror of nudity both in its dress and in the relentless critical attacks made on some artists, like William Etty, who persisted in devoting their lives to painting the nude. But their repressed sensuality was expressed in other ways in art, taking refuge in the idyllic distant world of Greece with its nymphs and Venuses, or in the fantastic world of fairies. In the Television and Radio Supplement I will give you a little more background information on the programme.

(T.B.)

UNIT 34 (Radio)

THE WHISTLER-RUSKIN TRIAL

Most often, this trial has been seen as a kind of crisis point in art. It has been regarded as a dramatic episode in the conflict between the Old and the New; Ruskin representing the earlier naturalist tradition, Whistler a modern, more interpretative art. This view of the trial is, I believe, misleading. Not only has the interpretative, or conceptual approach to art existed earlier, but it has characterised *most* of the art produced in the past. And naturalism in art? It's still with us – in photographic form, and in painterly and sculptural simulations of photographic form.

To consider the trial merely as a conflict between an outworn and an emerging style in art is superficial. Ruskin and Whistler represented two antithetical views not just about art, but about art's relation to society and the moral implications of these relationships. What is more, and ironic, is that *both* those views were generated to a certain extent by the industrialisation, and the concomitant commercialism, of society. (See the Television and Radio Supplement, and the Whistler paintings reproduced in the supplementary colour plate section.)

4 THE ANTHOLOGY

INDUSTRIALISATION AND CULTURE 1830–1914

As you read these two Units you will frequently be directed to certain passages in the Anthology. If you've already read those passages, I should like you to read them again in this new context of *Art and Industry*. Unless otherwise instructed, do not read the Ruskin and Morris extracts (Part Three, Sections M and N in the Anthology) until you complete the correspondence texts (Units 33–34) and before attempting the assignment.

5 ASSIGNMENT

This will be an essay, details of which are given at the end of Unit 34. It involves, particularly, the material of both Units (33 and 34). But it is also intended that you bring into the scope of your discussion relevant material from all other Units of the *Industrialisation and Culture* block (29–36). You will be asked to read and comment on two extremely pertinent, though little-known documents of the period. Their authors take diametrically opposite views on the mechanisation of art and its consequences. No harm will be done if you have a quick look at them now (p. 110 ff.).

6 CONTENTS OF UNITS 33 AND 34

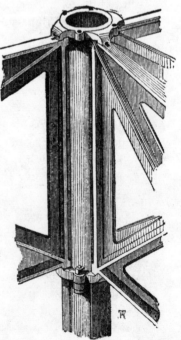

SECTION 1: BRITISH DESIGN BEFORE THE GREAT EXHIBITION OF 1851

1 HE French Revolution in 1848 was not without its repercussion on the design industry of Britain. It may well have acted as an accelerator which contributed to the ferment in British manufacturing which had just begun to move out of a period of inertness in the production of consumer goods.

2 A considerable amount of space was given to this revivification of manufacturing in the *Art-Union*, one of the two most influential art and design magazines of the period; the other being the short-lived but very effective *Journal of Design*. The view of the *Art-Union* in 1848 was that fear of Communism (a term often applied then to revolutionary movements) in France caused panic among the manufacturers and precipitated a rush of capital into London. With the production of competitive goods dislocated in France, Britain might now gain the edge in commanding world markets. Prices were falling in France, in textiles especially, and in 'objects of *vertu*' (as curios, antiques and ornamental art objects were collectively called).

The *Art-Union* became the *Art-Journal* from 1849

Wholesalers there were selling desperately. Not entirely successful in disguising its glee, the *Art-Union*, citing the economist Adam Smith and the much vaunted 'law of supply and demand', somewhat smugly urged the British to import and absorb French goods as much as possible to prevent being undercut in foreign markets and then to control the price of goods in those markets. There was now a great opportunity for developing new British markets at (temporarily) cheaper prices. France, it was said, would then lose her dominance in decorative arts manufacture and would have to fall back on agriculture. The recognised danger here was that filling British warehouses with French goods would for a period cause the unemployment of British artisans. But the 'pie in the sky' was Britain's eventual ascendancy over those markets. The sensible British worker, it was believed, would surely go along with the plan knowing that ultimately it would benefit him too (see Anthology L4).

3 By 1848, the conviction had become rather widespread that British goods were quite as artful in decoration and at least as cheap in price as similar articles in other European countries. British industry was apparently collecting its strength 'for a fresh career of competition with all the world'. There seemed to be little hesitation in entering a wider field of commerce and upholding the idea of free trade. It is not certain that 'cashing-in' on the paroxysm in France had any measurable effect, but it apparently gave impetus to a manufacturing nation now geared up for world-wide commercial enterprise in the utilitarian and ornamental arts.

4 Though many exhibitions of British manufacture had been held previously, and were again to open that year – not only in towns like Manchester and Sheffield but in at least four different places in London – it was felt that none of these, or even combinations of these, could do justice to the multitudinous products of British manufacturing. What was needed was one mammoth exhibition in which everything could be shown: 'The loyalizing effect of such an exhibition is not the least of its moral recommendations. Every man who visited it would see in its treasures the results of social order and reverence for the majesty of law'. So pronounced the *Art-Union*

in January 1848. Other benefits were similarly enumerated. Albert, the Prince Consort, already active in the promotion of British arts and manufactures as President of the Commission on the Fine Arts, was proposed by the editors as the directing spirit behind such an exhibition. This obviously was a 'feeler' to get government support and that also of manufacturers for the scheme. Though no mention was yet made of it being international it was obviously the first concrete suggestion which led directly to the Great Exhibition of 1851.

5 What was, in fact, the state of British manufacture and design in the 1840s? What was it that engendered such positive attitudes and willingness to do battle with competitors for a world market?

6 Though up till about 1810, most factories used water-power, behind most of the 'improved' manufacturing techniques was steam power. James Watt had perfected his steam engine in Birmingham in 1774, and by 1785 it was already adapted for use in powering factory machinery. Other improvements like Trevithick's high-pressure steam engine (1801–2), machinery like Nasmyth's steam hammer (1839), and hydraulic presses, opened up new and efficient systems for forming: stamping, moulding, pressing, cutting, and shaping, without which much of what we know as Victorian design might never have come into being.

7 Second, the conviction was gaining ground that utilitarian objects might also be works of art; that to whatever significant or in-significant use an object might be put, its value would be enhanced by endowing it with a rich ornamental appearance, **and that ornament itself could be equated with art.**

8 Third, as a result of that conviction, it became imperative that the men of art, of science and of manufacture must enter into a useful interchange. The *Art-Union* in fact conveyed this idea by the relevance with which it treated all three areas.

ON THE IMPORTANCE OF DESIGN TO MANUFACTURING

9 N the mid-40s there was a tendency to look back with disdain at the designs of the first decades of the century. The major criticism was that they were feeble in ornamentation. 'Modern design' favoured a generous use of ornament, which, however, should be tasteful. It was, however, readily admitted that gross and glaring absurdities were being perpetrated in the name of good design. Here is a typical comment from the period (1846). The intention is clear:

These absurdities were mostly noted where the symbolism was inappropriate. This will be discussed later

Mechanical improvements have kept following each other in rapid and unbroken succession: the machinery that is ten years old is already deemed out of date. We look forward with confidence to similar progression in the Arts of Design. We trust that the next decennial period of manufacturing history will exhibit as great an advance in beauty of production as the last has in facility of pro-duction. We trust that elegance will go hand in hand with abundance and that the ARTIST will adorn while the MECHANICIAN

facilitates, but this result must be sought to be obtained: the manufacturers must not only feel a general interest in Art, but they must make artistic principle a living element in their business. They must regard every advance made in Art as the opening of a new source of wealth to themselves. Political economy teaches us that value accrues to objects when they are rendered desirable; but articles can be rendered desirable as well by their beauty as by their utility.

This distinction between the 'artist' and the 'mechanician' is important and should be kept in mind

10 Which of these sentences best expresses the 'philosophy' of that passage? Tick the appropriate box.

(a) Objects that are not beautiful will soon be out of date.

☐

(b) Beautiful objects will make more money than useful ones.

☐

(c) Useful objects will make even more money if they are also beautiful.

☐

(d) Beautiful objects can be manufactured in greater abundance than can merely useful objects.

☐

'Art' was seen as the necessary ingredient in giving 'mercantile value' to manufactured products. The answer is (c).

11 There you have it in a nutshell. On that philosophy was based the whole complex activity of Victorian manufacture and design, from the growth of design training and schools of art, to an invigorated exploitation of old and new materials and production techniques. Art and industry were powerful allies, and with the probable saturation of the middle-class domestic market it became not only expedient but necessary to promote more foreign trade, already the mainstay of the Industrial Revolution. 'Elegance and abundance'; art and wealth. The conditions were just right for the organisation of a great and all-encompassing exhibition. It wasn't simply the desire for art and ornament that governed design at the time. The character of Victorian design was also dependent on the nature of the materials and techniques then available.

12 FTER reading Units 29–30, you should see fairly clearly that so rapid and extensive a development in roads, canals and railways could not have occurred without the development of the iron industry. In fact, while iron was an essential element in the mass-production of machinery, track and hardware in general, the canals and railways also directly accelerated the growth of the iron industry, linking the coal fields to the foundries and these to the canals and sea. A thriving iron industry is not only a perfect example of industrialisation in itself, it is a prerequisite for almost all aspects of industrialisation.

13 I cannot go into the developments in the eighteenth century which made it possible to make iron castings weighing several tons, or produce wrought iron girders hundreds of feet long. You can easily find this out for yourself if you want to follow it up at some time. But to make some points clearer in the television programme, I want, very briefly, to indicate the extent of the use of wrought and cast iron in engineering and architecture in the nineteenth century and explain the chief differences between the two.

14 Briefly, cast iron contains between 5 and 7 per cent impurities, chiefly carbon. These impurities make cast iron hard but brittle, a little like glass. It is, on the other hand, a fairly simple operation to make a casting, as you'll see in the programme, and is consequently cheap, unless complicated or hollow shapes are made.

15 In the hammering, rolling and slitting of wrought iron, however, most of the impurities are removed, producing a metal which is more resilient and which resists twisting and pulling strains better. Iron wire is a particularly supple kind of wrought iron and should give you an idea of its properties. Because of the processes of refining and forming necessary for wrought iron, it is more expensive than cast iron. Furthermore, the hammers and rollers produce fairly simple shapes (Fig. 1), which require welding or riveting together to form a structural girder. This adds to the expense.

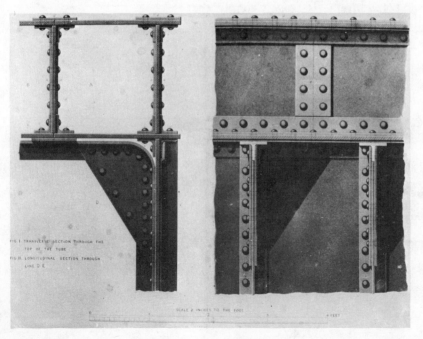

Fig. 1 Longitudinal and transverse sections of part of the Britannia Bridge (see Fig. 6). Note how simple the shapes are, mostly flat plates, 'L' or 'T' sections, riveted together. From: W. Fairbairn, Illustrations of the Construction of the Britannia and Conway Tubular Bridges, *1849.*

16 Now look at the following examples of eighteenth- and nineteenth-century engineering. These were much admired, particularly the railway stations, as examples of modern knowledge and daring, but were definitely not considered to be 'architecture' except by a very few critics. To start with, it was cast iron which inspired the more imaginative engineers (see Figs. 2, 3 and 5). But cast iron was unreliable. It was difficult to predict or detect faults in the castings, and meanwhile research into wrought-iron girder shapes, particularly the rectangular and circular varieties, and experiments with the suspension principle (see Fig. 4) convinced engineers that wrought iron (and from the 1880s, increasingly steel) was more practical for large spans. But, as you will see, cast iron went on being used for decoration, and for the particular jobs it could do well.

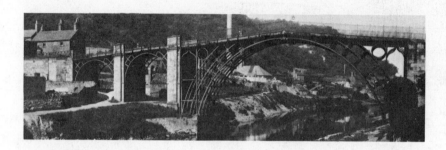

Fig. 2 The first cast-iron road bridge in the world, at Coalbrookdale. The parts cast by the Coalbrookdale Company in 1779. Central span 100 ft. 6 ins.

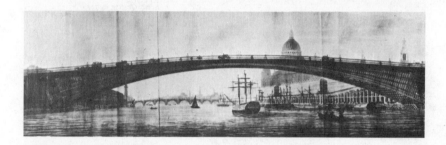

Fig. 3 The Select Committee of the Port of London were, at first, in favour of this project, by Thomas Telford, for a new London Bridge. (Published 1801. Span: over 600 ft. Clearance at centre: 65 ft. at high tide.)

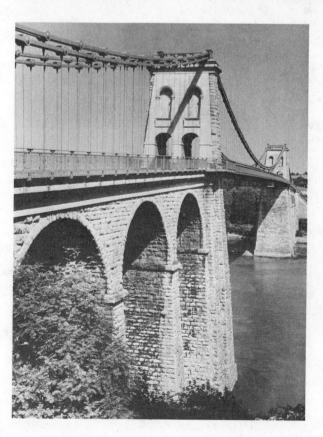

Fig. 4 Although an enthusiast of cast iron, Telford did as much as anyone to prove the suspension principle with its use of wrought iron. The Menai Bridge 1819–26. (Span: 579 ft.)

13

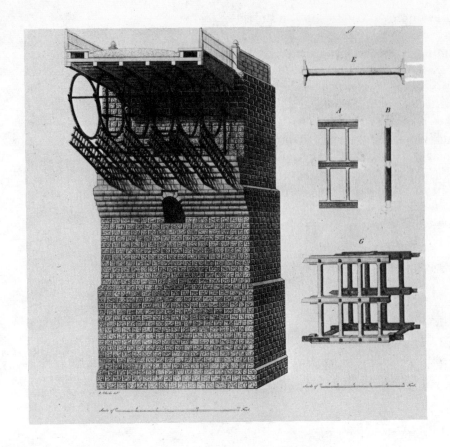

Fig. 5 *These structural details from the Sunderland Bridge 1796 (Span: 236 ft.), show how simple cast-iron units (A) can be linked together to form rigid arches (G).*

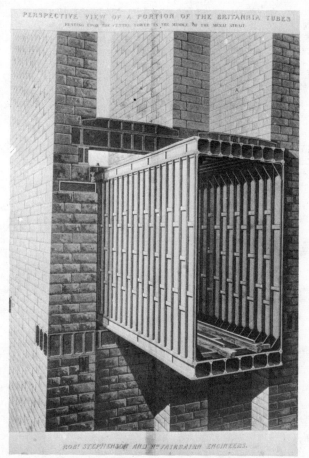

Fig. 6 *Cross-section of the tube of the Britannia Bridge, by Robert Stephenson, completed 1850. This wrought-iron tube, 1,511 ft. long, covered two clear spans of 460 ft. each. From: W. Fairbairn, Illustrations of the Construction of the Britannia and Conway Tubular Bridges, 1849.*

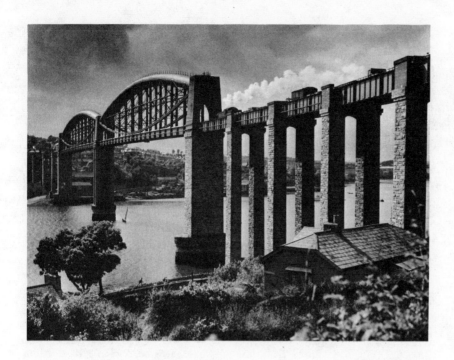

Fig. 7 *The Royal Albert Bridge, Saltash,
by Isambard Kingdom Brunel 1848–59.
(The two main spans: 465 ft. each.)
This bridge demonstrates again the amazing
structural strength of wrought-iron tubular
construction.*

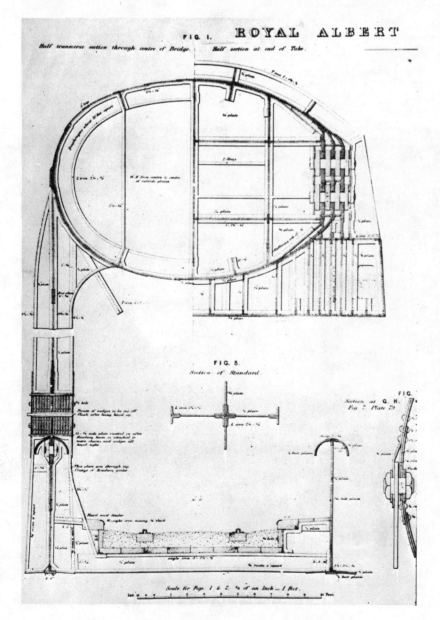

Fig. 8 *Cross-section of one of the great
tubular trusses of the Saltash Bridge.
From: W. Humber.* A Compleat Treatise
of Cast and Wrought Iron Bridge
Construction, *vol. II, Plate 80.*

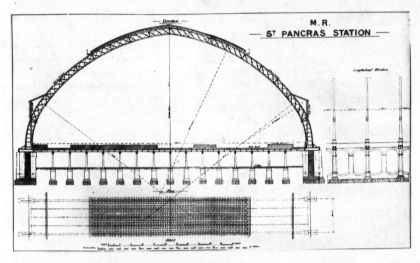

Fig. 9 The Sheerness Boat Store, G. T. Greene 1858–60. The entire 210 ft. façade is constructed from a framework of cast iron beams with corrugated, galvanised iron sheeting infilling. Cast-iron was still valued for its rigidity in functional buildings like this.

Fig. 10 St. Pancras Station, London 1863–76. Engineers: W. H. Barlow & R. M. Ordish. Span: 243 ft. Like all the great station spans, this roof is of wrought iron.

Fig. 11 Cast-iron decorative ebullience in the Waterloo Bridge, Bettws-y-Coed, Caernarvonshire 1815, by Thomas Telford. This is how cast iron could satisfy the desire to couple rigidity with decoration. See Fig. 15.

Fig. 12 Blackfriars Bridge, London, by Joseph Cubitt 1863–69. Here the structure is based on wrought-iron girders, but cast iron is used for decoration, in the spandrels, cornice and balustrade.

Fig. 13 Jamaica Street Warehouse, Glasgow 1855. The façade is all of cast iron and glass, very delicately used.

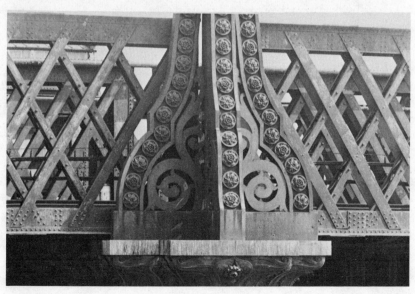

Fig. 14 Alexandra Railway Bridge, Blackfriars, London 1864. Built by Joseph Cubitt and F. T. Turner, the stark and brutal wrought-iron lattice girders are relieved by tough cast-iron connecting pieces and cast-iron columns.

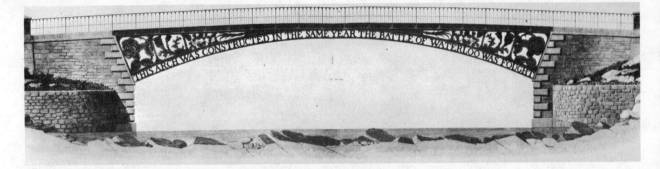

Fig. 15 Waterloo Bridge, Bettws-y-Coed (See Fig. 11). Span: 105 ft.

Fig. 16 Alexandra Railway Bridge, London (See Fig. 14). This detail of the great cast-iron terminal at the end of the bridge shows how ideally cast iron suited the aggressive industrial pride of the Victorian engineers; the detail shown is some twenty feet high.

17 These great engineering enterprises were strictly regulated by structural and economic constraints. But the nineteenth-century critics felt the need to embellish such crude functionalism, and this is where cast iron came into its own. Compare the raw efficiency of the Alexandra railway bridge with the monumental detail of the Waterloo Bridge, Bettws-y-Coed, or the delicate finesse of the Jamaica Street Warehouse, Glasgow (Figs. 14, 16, 11, 15, 13).

18 We'll be looking at several examples of decorative marvels in cast iron in the television programme, and in the latter part of this section, but to make the critical viewpoint of the nineteenth century a little clearer, here is a summary of opinion from Matthew Digby Wyatt's *Metalwork* of 1852. This extract shows clearly how important an issue functionalism was, and how difficult it was to strike a happy medium between ugly usefulness and picturesque inefficiency.

IRONWORK, AND THE PRINCIPLES OF ITS TREATMENT

As in philosophy we find a certain number of the thinking world unwilling to concede value to anything the utility of which they cannot clearly perceive, so, among those practically engaged in the great work of manufacturing production, a large body of individuals may be found who yield a title to merit, only in proportion to the degree of utilitarian contrivance manifested by the designer of any of the staple articles of commerce. It is to the class of men in the iron trade who hold such tenets that we are mainly indebted alike for wonderfully-ingenious and delicately-adjusted beams, girders, machines, roofs, &c; and for the particularly ugly forms in which, until within a very recent period, these objects have been habitually designed. There are, again, others in philosophy who do not allow that any narrow scale of human wants and

necessities can correctly determine intrinsic value in art or science; while, in the province of manufacture and its design, many may be met with who, dwelling on the existence of an inherent grace in form and proportion, attach a secondary value to the utilitarian portion of every object – men who, in the speciality of iron-work, would determine the merit of a pump or a lamp-post by the possession of certain picturesque or graceful characteristics, rather than by the quantity of water raised by the one, or the facilities for the distribution of light afforded by the other.

To the first class of bigots (the Utilitarian), we may fancy, belong the careful cast-iron Constructionists, who generally build railway sheds *ad infinitum*, and bridges *ad nauseam*, with more skill than taste; to the second (the Idealist), the poetical and sometimes tumble-down genii, who raise imaginary towers on 'the baseless fabric of a vision', cover dog-kennels with crockets and finials, turn stoves and clocks into cathedral façades, make bridges where water flows not, and too often sacrifice comfort and convenience to ornament and effect.

And he concludes:

No successful results can be attained in the production of beautiful iron-work, or beautiful anything else, until one of three things takes place – either, first, until the manufacturer and designer are one individual doubly gifted; or, secondly, until the manufacturer takes the pains to investigate and master so much of the elements of design as shall at least enable him to judiciously control the artist; or, thirdly, until the artist, by a careful study of the material and its manufacture, shall elaborate and employ a system of design in harmony with, and special to the peculiarities so evolved.

IRON AND ART

19

20

Fig. 17

THE invention of many new manufacturing processes and decorating techniques in the 1840s transformed the traditional use of such materials as iron, wood and papier mâché.

As rolled (wrought) iron sheet replaced cast iron in heavy industrial use, as in railways, new uses for cast iron were found in the manufacture of ornamental utilitarian objects. Many of the iron-founders who pioneered the structural use of cast iron in civil engineering, also led the way in domestic design. The Coalbrookdale Co., for instance, displayed a heavy, lush, but rather silly, fountain in the Great Exhibition (see plate V). Improvements in casting methods went hand in glove with the heightened taste for ornament. The way was now open to the relatively inexpensive production of lavishly embellished chairs, tables, umbrella stands, lamp-posts and gates. Greenhouse and garden ornaments 'took the cake' for sheer exuberance in design. The multitudinous trappings of decorative art from every conceivable place and period in history became the Victorians' dictionary of design – though its careless use was not left unchallenged by more discerning critics.

21 To keep cast-iron objects heavily ornamented, yet light in weight,

was, of course, a major consideration, and happily, the demands of ornament and weight, in addition to that of structure, could be satisfied by designing open, reticulated, motifs. Serpent and scrolls, branches, vines, and a large variety of leaf forms were often put to this triple function. Due to the openness of the designs, a great saving in weight and material was realised. And, hardly inconsequential, finishing was neither critical nor expensive as it is, for example, in the clean-cut machined objects favoured in our own century.

Fig. 18 Cast-iron flower stand made by Eagle Iron Foundry, Leamington 1846. Despite its elegance, it was criticised as defective because of the admixture of stylistic motifs. Purity of ornament, consistency in style, was considered essential.

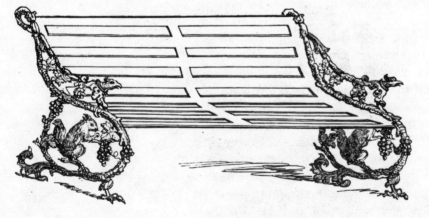

Fig. 19 Garden chair in cast iron, 1846. Though on one hand this was applauded for being imaginative and different from the ordinary run of things, it was still believed to show 'defects of a grave character'. Notice the bird's foot, growing from the vine stock. Station furniture for railway companies provided a huge market for cast-iron products.

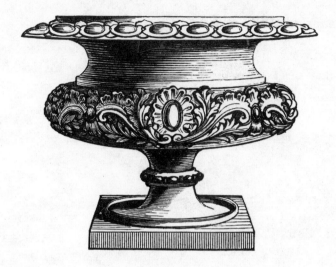

Fig. 20 Ornamental garden vase in cast iron manufactured by the Eagle Iron Foundry, Leamington 1845. Some critics frowned upon the use of iron for vases, even vases for the garden. They preferred them in ceramic materials.

CRITICAL STANDARDS

22 The term 'elegance with strength', which the Eagle Iron Foundry of Leamington used to describe its products, was not without meaning. For despite the jaundiced view our own contemporaries have of Victorian design and the prevailing conviction that it epitomised a kind of anarchic tastelessness, there was much proselytising in those days on behalf of 'purity of style', 'uniformity of character' and other discriminating canons of design. A well-informed visitor to the famous Coalbrookdale Cast Iron Manufactory enthusiastically praised the inventiveness and skill displayed in the decorative mastery of the somewhat obdurate material, as in this chair here.

23 Let it not be thought that the Victorians were without artistic standards concerning the use of materials themselves, or uncritical of the grotesque, often freakish, excrescences to be found adorning many objects made in the period (will not some future critics find our own design puritanically sparse – or unimaginative?). The Trafalgar Square fountains, for example (as they were in the nineteenth century, before they were re-designed in 1939), came in for abuse as absurd jumbles of architectural monstrosities, as also did objects which neglected to provide either the appropriate decorative symbolism or the proper material environment: floral ornaments on hat stands do not go with headpieces; colourless glass and metal next to one another destroy the purity and brilliance of the metal; the effete effects of *chêne* silk should not be printed on cotton, etc., etc. (See further comments of this nature in Anthology L7, L8.)

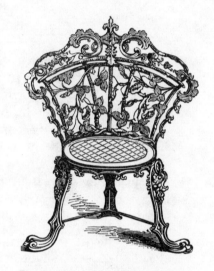

Fig. 21 This cast-iron chair was praised as superior in execution, 'designed with great force and spirit' (1846).

24 Just as the modern 'man of taste' has been educated to abhor too much ornament, preferring instead the clean-cut functional machined look, his counterpart in the nineteenth century was revolted by simple design. Fountains, for example, like those erected in the centre of Brighton around 1846, were thought to be a disgrace to a civilised community. Why? Because 'artistically' they were so *parsimonious*; because ornament was equated with endeavour, and endeavour with good.

25 What the Mandarins of design wanted above all was to marry usefulness with artfulness. As much of each as was possible in a single object. 'Art is the best aid of Manufacture; the Manufacturer has no ally so valuable as the Artist'. These are phrases one en-

Fig. 22 Cast-iron bench (1846). This kind of design was entirely acceptable. But the dog's head, a contemporary critic insisted, was too literal. He liked the snake.

counters frequently in reading through documents of the period. And though many shotgun weddings were thus encouraged between the utilitarian vessel and the artful embellisher, resulting in an awkward co-existence, it cannot be denied that the *best* Victorian design is both imaginative and appropriate.

GUTTA-PERCHA

26 O new material that made its appearance in the Victorian era more completely revealed the manufacturing cunning of British industry than the latex from the East Indies called Gutta-Percha, and hardly a better example could be cited of ecological madness in the utter disregard for its conservation. Tough and impervious to water, completely malleable when heated, it was no idle boast when it was said in 1848 that 'Gutta-Percha is destined to effect a revolution in many of the Manufactures devoted to the Industrial and the Ornamental Arts'. A most versatile substance, Gutta-Percha was employed in the manufacture of basins and buckets, boot soles and door handles. It had extensive applications to book binding. Water pipes were made of it and it was used for electrical insulation and to coat the wires of trans-ocean telegraph lines. Anchor floats and buoys, sou'wester hats were also produced from Gutta-Percha. In 1851 a Gutta-Percha boat, used in an arctic rescue mission in search of Sir John Franklin, was found highly satisfactory. It was said, not unreasonably, that that material had become 'one of the necessities of civilised life'.

27 Highly ductile at temperatures of about 200° Fahrenheit, Gutta-Percha was very suitable for moulding, as it turned extremely hard on cooling. Unlike india-rubber it was not soluble in oils normally used with machinery, and therefore replaced things like bosses, rollers and drive belts and other components affected by oils. It was useful in chemical, dye and print works, with syphons, funnels, carboys and measures made of that material. Gutta-Percha could be softened with boiling water and rolled into thin sheets. Light in appearance, it could be tinted with any colour desirable. In short, in its versatility, but for its lack of elasticity, it was at least equal to india-rubber and it replaced many of the functions of that material in those years.

28 Nor were these functions of Gutta-Percha confined only to the 'useful arts' for it was perfectly suited to embellishment in the decorative arts. There, the penchant for simulating one material with another, and its economic feasibility, was augmented by the introduction of that material. It meant that now hardly a limit could be placed on the decorative configuration and treatment of surface, and what had painstakingly been done in wood carving, wrought iron, and cast alloys could now be duplicated exactly and cheaply in Gutta-Percha. Counterfeits these objects may have been, anathema, even, to critics like John Ruskin, but contemporary eulogies to the efficacy of Gutta-Percha testify to its importance in the manufacturing arts.

29 The surface of Gutta-Percha could be rendered extremely smooth to

give the appearance of metal. It could also be made to look like wood. It lent itself to polishing, making it easy to simulate the lustre of japanning. It was made by moulding, stamping, embossing or casting into various articles of use: cornices, brackets and mouldings, panelling, mosaics and other architectural ornaments.

30 Gutta-Percha could be mixed with several materials to impart to it a variety of textures. With cotton or linen threads embedded in it it made excellent waterproof fabrics. Gutta-Percha threads introduced into other fibrous materials gave great strength to woven and plaited objects. There were several ways in which it could be used in the manufacture of books; even a system of letters and maps in relief for the blind was proposed. Ink stands, handles for tools, dress models, snuff-boxes, goblets, flower pots, buckets, mirror and picture frames, plates and trays; and for the hard of hearing, church services now had a new meaning with the invention of telephone tubes of that material connecting the pulpit to the pews: these, and many more products, were manufactured in Gutta-Percha.

31 In reading of Gutta-Percha and its multiplicity of uses, you will almost certainly have brought to mind a modern material with the same kind of versatility. What is the modern equivalent of Gutta-Percha?

P.V.C., probably. Like P.V.C., which needs a plasticiser to make it pliable, Gutta-Percha too, not in itself pliant, had for that purpose to be combined with other materials.

32 As for the arts and crafts, very few of them were untouched by that omnipotent substance. Into veneers of Gutta-Percha were pressed metal, wood and other materials to produce tesselated and inlaid decorations. It was used to ornament a thousand different objects – to endow them with art as well as utility – that conjunction so desired in Victorian manufacture. Moulds could be taken of a multiplicity of objects with ease and with absolute fidelity, and coupled with the recently discovered electrotype process, metal-coated facsimile copies of rare objects could be had at little cost.

33 Here is a contemporary description of the material:

> The Gutta-Percha may be worked into any form and almost any colour may be given to it. Cornices of the most elaborate designs in imitation of several kinds of wood, are manufactured of it; and from the toughness of the material even the most delicate representations of foliage are not liable to injury. Copies of old oak panelling taken in the Gutta-Percha, which we have seen, have preserved in the most remarkable manner every trace of the original. The grain of the wood, its abrasion by age, its colour and, of course, its pattern being preserved with the utmost fidelity. Impressions taken from coins and medallions are really beautiful and statuettes may be copied by it with great truth and at a comparatively small cost. (The *Art-Union* 1848)

34 This 'necessity of civilised life' was brought to light in 1842 by an Englishman in government service in Malaya. Like india-rubber, the sole use of which for many years was the erasure of unwanted pencil marks, the existence of the Gutta-Percha latex was known to Europeans much earlier. Obviously, the mighty British industrial force had finally galvanised consumer demand to such a degree

that a new look at materials and manufacturing techniques had become imperative. Gutta-Percha, it was quite ingenuously stated at the time, had come upon the scene 'when every effort of thought is directed to the application of known truths to the useful purposes of life and when the economic value of every product of nature is carefully studied. . . .'

35 Gutta-Percha was first known in Britain as a curiosity, and was then called Mazer-wood. It was re-introduced to the British public in 1842 or '43 by a Doctor Montgomerie who had known of its existence 20 years earlier while in the medical service to the Residency in Singapore. The advantages of this substance over india-rubber in the manufacture of accessory parts to surgical instruments had struck him and he made the information available to others. For his pains Dr. Montgomerie was awarded the gold medal of the Society of Arts. But to Mr. Charles Hancock, to whom this knowledge was accidentally revealed, goes the plum. Hancock was a painter of all sorts who dabbled in science, especially as it concerned art, and it was he who prudently and hastily took out the first patent on Gutta-Percha in May 1844 and at the same time formed the Gutta-Percha Company. A year later, in 1845, according to official figures published in the Great Exhibition Catalogue, 22,500 lbs. of Gutta-Percha were imported. In 1846, the figure shot up to 715,200 lbs.

36 By 1848, when the first plans were put forth for the Great Exhibition, almost every branch of manufacture in Britain had found some use for the new material. In the first seven months of that year, no less than 2,880,000 lbs. of the latex was imported into Britain from the Island of Singapore where the Gutta-Percha tree grew in abundance. The supply was plentiful elsewhere, the trees growing wild in the forests of the Malay peninsula, in Borneo, Sumatra and north-east in the Phillipines. These trees also provided fruit, edible oils, and what was then known as 'ardent spirits'. Some of them, 50–100 years old, measured as much as 6 ft. across and grew up to 60–70 ft. high, though the yield in latex, even from such great trunks, was only 15–20 lbs. each.

The tree from which this latex was extracted is botanically designated, Isonandra Gutta; its native name was gutta percha.

37 The rapacity engendered by the demand for Gutta-Percha caused the destruction of the trees, for though it was possible in a controlled system for the latex to be extracted by tapping, the prevailing method – the quickest and most immediately profitable – was to cut the trees down. It was already recognised by mid-century that the demands of industry were encouraging the wanton destruction of the Gutta-Percha forests. Those concerned seem to have been extraordinarily indifferent to this erosion of resources. Some other method, they assumed, would be found to collect the juice and in any case it was to them a consoling fact that other areas like Borneo, rich in Gutta-Percha, were yet untapped.

38 By 1876 it was officially recognised that there was a severe shortage of Gutta-Percha. It was estimated that in the previous year about 600,000 trees had been destroyed in providing industry with the latex, but too little had been done, too late, and by the end of the century Gutta-Percha was no longer a viable material commercially. This is a prime example, perhaps the first in modern industrial society, of the callous disregard for the control and conservation of natural resources, of sheer ecological mindlessness; and it was a presentiment of things to come.

39 Another material rejuvenated by the industrial know-how of the '40s was papier mâché. Traditionally it was employed almost predominantly in the ornamental relief of plain surfaces: ceiling mouldings, rosettes, fret-work and other interior decorations. In use at least as early as 1760, it had largely replaced plaster moulding which itself had earlier supplanted the use of stucco.

40 To what degree can the use of a new material, or the new use of an old material help determine a style? Was it simply that materials suitable for casting led to ornament because they could be used to produce a chair in 'rustic wood' as easily as in any other form? In a way this raises the old chicken and egg question, for is it not also true that a change in taste itself brings into prominence those materials and techniques through which it can best be expressed? Papier mâché is a case in point here.

Re-read this paragraph carefully

Fig. 23

41 Papier mâché was one of the staple manufactures of Birmingham, having been used there since the beginning of the century – though it was known elsewhere much earlier. Much of it was produced in London too. One large firm in 1846 is known to have employed between 300 and 400 people. Using steam power and presses papier mâché objects were first made in moulds about 1836, but a

Fig. 24 *Papier mâché frame by C. F. Bielefield, 1847.*

Fig. 25 *The 'Day Dreamer'. An easy chair designed by H. Fitz Cook, and manufactured in papier mâché by Jennens & Betteridge of Belgrave Square and Birmingham. Shown in the Great Exhibition. A good example of overloading in symbolic meaning, the Exhibition catalogue describes it as follows:*

'The chair is decorated at the top with two winged thoughts – the one with bird-like pinions, and crowned with roses, representing happy and joyous dreams; the other with leathern bat-like wings – unpleasant and troublesome ones. Behind is displayed Hope under the figure of the rising sun. The twisted supports of the back are ornamented with the poppy, hearts, convolvulus and snowdrop, all emblematic of the subject. In front of the seat is a shell, containing the head of a cherub, and on either side of it, pleasant and troubled dreams are represented by figures. At the side is seen a figure of Puck, lying asleep in a labyrinth of foliage, and holding a branch of poppies in his hand. The style of the ornament is Italian.'

decade later, with more up-to-date presses and forming techniques, the pulp could be subjected to enormous pressures and made to assume almost any shape. It was thus possible, for the first time, to give it a structural strength previously unattainable. Not only could one now manufacture papier mâché simulations of any ornamental surface rendered in wood carving or other plastic materials, but having once been fit mostly for making trays, within its new domain were such items of furniture as flower-stands, sideboards, tables, consols, piano casings and baby cots. It could, furthermore, be given greater strength with wooden cores or iron armatures, so even things like beds, chairs and sofas could be made strong and durable in that material. Papier mâché furniture was surprisingly sturdy for all its lightness, and in some ways it was superior to wood since delicate projections could not so easily be knocked off.

Fig. 26 *Inkstand by Jennens & Betteridge (1846). Do you notice anything odd about this object? A peculiarity of its design? If you hadn't been told that this inkstand was made of papier mâché, what material would you have judged it (from its appearance) to be made of? Compare it with the papier mâché ceiling rosette illustrated at the beginning of this section, and with the mirror frame. Can you see that the character of the rosette reflects qualities of a material like plaster, and the frame those of carved wood? The inkstand, however, allowing for the distortion produced by the severe lines of the engraving, has about it a metallic look: machine-formed, pierced, and a hard, un-resilient surface not unlike the ornamental iron object shown here as a vignette, before para. 12.*

42 Within a very few years large quantities of papier mâché objects were exhibited in the Crystal Palace, and if you study the page from the official catalogue (below) you will see that they make an obvious contribution to the furniture, upholstery and paper hangings section.

124 STEEVENS, J. Taunton, Des. and Manu.—Cabinet, made of walnut-wood, grown near Taunton, Somerset, carved and enriched with panels of raised embroidery, &c. by Miss Kingsbury.

125 BAMPTON, J. A. 49 Union Passage, Birmingham, Des. and Inv.—Specimens of material produced from moss or peat, to be called moss-wood. Specimens of a plastic material made from moss and lime. Specimens of pressed moss fibre.

127 CLARKE, J. Birmingham, Des. and Painter.—Designs of armorial bearings, including seventy-four coats of arms and crests.

128 LANE, T. 91 Gt. Hampton St. Birmingham.—Articles chiefly in royal patent pearl glass; papier-mâché table; work-table; cheval screen; pole-screens; reading-table; cabinets; chess-table, &c. Specimens of patent gem painting on glass, invented by Miss E. Tonge, Boston, Lincolnshire.

129 DAVIES, G. C. 7 Brearly St. West Birmingham, Des. and Prod.—Papier-mâché work-box, decorated in the Elizabethan style. Japanned papier-mâché box. Glass tapestry panel, a new style of decoration for rooms, furniture, &c.

130 EARLE, J. H. 50 Upper Marylebone St. Des. and Painter.—Folding screen : encaustic painting illustrating the story of Cupid and Psyche. Table-top imitation of buhl.

131 HALBEARD & WELLINGS, 45 St. Paul's Sq. Birmingham, Manu.—Papier-mâché toilet table of Elizebethean design. Large cabinets, &c. Series, illustrating the manufacture from the raw material to the finished article.

132 FOOTHORAPE, SHOWELL, & SHENTON, Birmingham, Manu.—Ladies work-tables, drawing-room ornament-stand, small cabinet, writing-desks, jewel-boxes, folios, tea-caddy, ladies' reticule, hand-screens, trays, &c.

133 LEE, L. 118 Bedford St. South, Liverpool, Prod.—Fancy table, painted in enamel, on prepared wood.

134 THOMPSON & WORTHY, Durham.—Ladies' writing desk.

135 DAWES, B. 20 Carlisle St. Soho Sq. Manu.—Circular table with top, made of a rare species of cedar, &c. Lady's toilet-table and chair of tulip-wood, inlaid with purple wood.

136 McCALLUM & HODSON, 147 Brearley St. Birmingham, Manu.—Papier-mâché tables. Multiformia music-stand. Cabinet on stand. Ladies' portfolio and work-table. Bracket-glass, with branch lights. Tea-caddy, new trays, &c.

137 SUTCLIFFE, I. 27 Gt. Hampton St. Birmingham Manu.—Ornamental papier-mâché trays, loo-table, work-tables, vases, folios, caddies, work-boxes, inkstands, &c.

138 TURLEY, R. Birmingham, Manu.—Large folding screen; large loo-table; oval table; gothic tables; sexagon table; cabinets; trays; chairs; work-tables; dressing cases, &c.

139 HOPKINS, R. P. Wimborne, Dorset.

140 BROWN, J. 71 Leadenhall St.—Metal bedstead.

141 SMITH, G. F. March, Cambridgeshire, Des.—Specimens of painting, in imitation of various marbles. Painting, in imitation of oak, for interior or external decorations.

143 DAVIS, G. Southampton, Des. and Manu.—Specimen of marbling, graining, and varnishing, on paper.

144 GORE, & CO. Speenhamland, Newbury, Des. and Painter.—Screen, painted in the old English illuminated style, and recording events of English history.

145 BELLEABY, W. York, Des.—Cabinet of oak, having ornamental panels of burnt white wood.

146 FINDLEY, C. V. 36 King St. Leicester, Des. and Manu.—Carved chair of Leicestershire oak.

147 BARKER, G. 2 Brook St. Bond St. Inv.—Perforated flexible screws, with nuts and hooks, for hanging pictures.

148 MEAKIN, —, Baker St. Portman Sq.—Registered chair.

149 COTTERELL BROTHERS, Bristol.—Paper-hanging, for a dining-room.

151 FLETCHER, R. Derby, Inv.—Crystal granite paper-hangings (washable).

152 RAMUZ, A. 17 Frith St. Soho. Prod.—Patent mechanical billiard table. Patent sofa, containing bedstead, &c. Models of bedstead, ottoman, &c.

153 RIVETT & SONS, 50 Crown St. Finsbury Sq. Des. and Manu.—Mahogany pedestal sideboard.

154 HOPKINS & SON, Birmingham, Manu.—Shade, with improved action.

155 MARTIN, J. Southampton Row.—Carved chair, richly worked in wool.

157 BIELEFELD, C. F. 15 Wellington St. Inv. and Manu.—Papier mâché articles, manufactured by patent machinery in a new material. Bust of Flaxman. Bracket figure of an angel, architectural ornaments, &c.

159 GREIG & SON, 27 Farringdon St. Des. and Manu.—Winged wardrobe, of fine Spanish mahogany, with carved pediments, trusses, doors, &c.

160 WILLS & BARTLETT, Kingston-on-Thames.—Bookcase, of walnut-tree, combined with other woods in relief. Pair of candelabra, of three woods, in their natural colours.

161 HOLLAND & SONS, 19 Marylebone St. Ranelagh Works, Belgrave Sq., and 23 Mount St. Manu.—Bookcase, founded on the cinque-cento style, composed of British woods and marbles; designs by Macquoid. Console table and glass. Water lily circular table.

162 TROLLOPE & SONS, 15 Parliament St. Westminster, Des. and Manu.—A sideboard in oak. A bed-room suite, consisting of bedstead, wardrobe, drapery table, toilette glass, and washing-stand, in satin wood, inlaid in marqueterie, worked with woods of their natural colours. A drawing-room chair, carved and gilt. Decoration for a ceiling in light arabesque.

163 DE LARA, D. 3 Alfred Pl. Bedford Sq. Des. and Inv.—Illuminated design on vellum, in colours and gold, forming a chess-table with arabesque borderings, &c.

164 MORANT, G. J. 91 New Bond St. Des. and Manu.—Specimen of rich decoration. Circular table, designed from a suggestion of the Duchess of Sutherland. Ornamental frame, made for Her Majesty. Cabinet of tulipwood. Carpet, &c.

165 NUNN & SONS, 19 Great James St. Bedford Row.—Des.—Chess table, made of Italian walnut-wood, ornamented with bas-reliefs in electrotype silver. Chessmen, carved in ivory.

165 CUNNING, W. Edinburgh, Manu.—Improved drawing-room rocking-chair. Models of bedsteads, in brass and iron.

166 BANTING, W. & T. 27 St. James' St. Des. and Manu.—Circular marquetrie table. Sideboard made from oak grown in Windsor Forest. Satinwood china cabinet. Secretaire cabinet of kingwood, with English china inlaid. Oval table, Amboyna wood.

168 FOX, T. 93 Bishopsgate St. Within.—Bedstead of walnut tree, gilt, with lofty canopy and drapery of blue silk.

169 DURLEY & CO. 66 & 67 Oxford St. Manu.—Canopy bedstead of walnut-tree, in the Elizabethan style, with furniture of rich English brocatelle. &c.

170 SNELL & CO. 27 Albemarle St. Manu.—Chimney glass, the frame carved in walnut-tree. Walnut-tree cabinet. Sideboard. Satin-wood wardrobe. Oval table, with marquetrie border. Library table. Carved fire-screen, &c.

171 WEBB, J. 8 Old Bond St.—Rock crystal vase and plateau, of the 16th century, with ornamental mountings of the present period, enamelled on gold by Morel. Chess table, &c.

Fig. 27 Here is a curtain ornament, metal, made in Birmingham. Compare it with the papier mâché inkstand. Which form seems more 'true' to the material with which it is made? That was a leading question, for I would argue that there is no 'true' rôle for the decorative use of plastic materials like papier mâché. By their very nature they lend themselves to the imitation of other, less malleable, materials. Should papier mâché, to be used 'properly', always have a pulpy look? Think about it.

'Japanned ware' : tinned iron sheet or papier mâché to provide a suitable surface for a hard and brilliant lacquer finish as in Japanese lacquered papier mâché objects.

Fig. 28

Cheapness, of course, was again an important consideration as was the high degree of decorative modelling to which this material could be subjected. As to durability, papier mâché had great powers and even today one finds in Victorian houses, as good as new, ceiling mouldings and rosettes made of it 100 years ago. It was at its best resistant to moisture and decay, and repellant to insects. It could be cleaned with soap and water. It could be bent by heat or steam. It could be sawn, planed, carved and sandpapered as wood. Papier mâché objects took readily to a great variety of surface treatment and lent themselves particularly well to gilding. But above all, as far as art is concerned, like Gutta-Percha, it was a plastic material and was eminently adaptable to ornamentation and mass-production.

THE ELECTROTYPE

43 F all the objects produced in the 1840s none could match, in fineness of detail, those made by the electrotype process discovered about 1838. By using a galvanic battery cell it was possible to deposit a fine film of metal on the most fragile natural forms or on casts made from them. Nature herself often collaborated in the process. Flowers and insects could actually be coated with so delicate a layer of gold, silver or copper, that each stamen and hair of the model was preserved. John Ruskin would have found these, abominable corruptions of nature and perfect symbols of the depravity of the machine mind, but all indications are that the average Victorian gloried in such cleverness and beauty. The electrotype was for sculpture, what photography was for painting. At Messrs. Elkington's London showrooms and at the Museum of Practical Geology in Craig's Court, fruit and flowers, ferns, moths, dragonflies and even lizards and birds were encased – Goldfinger style – in gorgeous metallic tombs for posterity. But of course, apart from such demonstrations of technical skill, electro-plating was of inestimable importance in manufacturing not only art objects but industrial products too – and still is today.

In 1851, about 500 people were employed by Elkington, and about 30 other British manufacturers were licensed to use the process

CARVING BY MACHINERY

44 New techniques which promised to 'serve the high purpose of teaching the people and improving their powers of perceiving the beautiful' included picture frames 'carved' by machinery. Papier mâché lent itself well to this end and so did a method for stamping, under pressure, simulated carvings in picture-framing material. The most delicate work done by hand could now be duplicated, it was said, by machine. The process was simple. A length of soft wood was passed under a gun-metal roller cast in the desired pattern with pressure applied by steam-engine. The imprint was made on the wood with every delicate tracery engraved on the roller accurately reproduced. This was seen as a fitting counterpart to graphic reproductions of the day. An art for the people, it would enable 'him who buys a print for a shilling to place it in a worthy frame for another shilling – or very little more'. With other processes based on an earlier invention for copying sculpture by James Watt (see Unit 34, para. 171), wood could actually be carved, not stamped, by machinery following the contours of a master pattern, and as it was then said, 'indistinguishable' from carvings in human hand (the rough-machined piece was in fact usually finished by hand). IT WAS BELIEVED BETTER TO HAVE INEXPENSIVE CARVINGS OF EXCELLENT DESIGN BY MACHINE THAN INDIFFERENT (INFERIOR) ONES BY HAND AT THE SAME PRICE. The parallel situations in the arts of pictorial reproduction are obvious, and here is the basis of much discussion, not to say controversy, today: that is, the value of the ORIGINAL, against that of the REPRODUCTION. This, you may remember, was one of the subjects discussed in a radio broadcast which went with the *Introduction to Art* (weeks 11–12).

45 The discovery of new processes went on, unabated, and increasingly
those things which had been made artful by hand were supplanted
for better or worse by the machine. And machines and machine
processes were themselves supplanted by other machines and pro-
cesses. The old Jacquard loom, for example, from the very beginning
of the century, used a quite remarkable system for weaving – some-
thing like the modern punch card. Moving rolls or leaves of perfor-
ated paper or card controlled the action of needles which slipped
through the holes as they appeared, carrying out the pattern of
design. By 1860, *electricity*, though in its primitive form, was used
with the perforated cards, activating the needles by electro-magnetic
means, and rendering the system much more efficient. The invention,
in the nineteenth century, of mechanical processes for the reproduc-
tion of works of art, is discussed in more detail in Section 3, Unit 34.

THE TEACHING OF ART AND DESIGN

46 LREADY by 1846 the designs produced at the
firm of Matthew Boulton and James Watt (of the
famous Birmingham Soho works) were considered
feeble in ornament and old-fashioned. And at the
same time critics were warning that modern
design was perpetrating 'gross and glaring
absurdities' – all the more readily to encourage
manufacturers to lend financial support to the
proliferating schools of design. For too long, it was felt, art had been
separated from manufacture. 'Men worked as machines', labouring
without instruction and without art, but now 'an enlightened
government' has helped to stimulate a change: 'Our wealthy capital-
ists and manufacturers have by their own enterprise established
[design training] on their own works', and the *Art-Union* wrote
enthusiastically, in 1847, that 'Exhibitions of the Fine Arts and
Expositions of the Manufacturing and Mechanical arts are now
common to all our large towns; and we defy the greatest sceptic to
doubt that there is real progress'.

47 Between 1842 and 1846 government schools of design were estab-
lished in most of the large provincial, and especially manufacturing,
towns. The Manchester School of Design was opened in 1842, as
were those at York and Newcastle-upon-Tyne. In the following
year the cities of Coventry, Sheffield, Nottingham and Birmingham
could boast new schools. In a few years that at Birmingham, for
example, had enrolled 214 students. Local authorities were in a rush
to stake their claims with the government for schools of design.
Glasgow began operating in 1845. Paisley, with a population of
60,000, began building its design school in 1846, by which year
Nottingham's was already expanding into a new building. In 1846,
too, The Potteries were proposing schools at Stoke and Hanley.
Leeds got stirring that year and Norwich opened its doors in
January to about 80 male and 80 female students, mainly for evening
study. In London, the long established Government School of
Design, located in Somerset House, enrolled 200 students yearly.
A little farther down the Thames, Spitalfields had, by 1846, over
200 students concerned mainly with silk manufacturing; other
schools were also concerned with the kind of product produced or
available locally. In this sudden awakening to the need and potential
of design, other educational institutions established drawing classes,

mostly for evening study, to help the aspiring designer on his way. As in Manchester, local manufacturers often contributed to the running of the schools and gave prizes for such dubious, yet perhaps revealing, accomplishments as the best outline drawings from antique casts and shading. This was one of the things which caused the formation of a Parliamentary Commission which harshly criticised such practice.

48 At the Manchester School of Design, students began by drawing and modelling from geometrical figures, and then progressed to ornamental casts. Depending on the special field contemplated by the student, the training included shading and other means of rendering volumes. Figure drawing was taught to enlarge ideas of form and sharpen observation but in most cases with ornamentation ultimately in mind. At the next stage, the study of painting was taken, mostly from still-life, mainly with an eye towards the exploration of different media. And finally, at the end of the art part of the course came the *pièce de résistance*: painting and drawing from a living model. The design studies which followed included so-called 'principles of natural form' along with a kind of 'increase your image-power' ingestion of styles of past art ranging from Egyptian and Hindu to the often cited advantages of Gothic, Elizabethan, Louis Quatorze and Louis Quinze. Drawing from flowers and plants and from humans and animals was again approached for its ornamental usefulness. With the conviction that the designer's enlightenment can only be found in the 'highest arts', throughout the course of studies the 'principles' of fine art were drummed in. A not dissimilar pattern governed other schools of design. Do you see how this kind of training from past styles was itself a major factor in the *eclecticism* of Victorian design?

N.B. the TV programme: 'The Nude in Victorian Art'

49 There was, of course, a different species of schooling in design for the 'craftsmen-finishers'. The Government School of Design in Birmingham, as an example, enrolled 170 students in the following, mostly vocational, studies in 1846:

Engravers	16	Glass painters	3
Japanners	24	Clerks	6
Die-Sinkers	26	Gilt tray-makers	1
Lamp-makers &		Jewellers	3
Brass-founders	18	Iron-founders	1
Architects	13	Black ornament-	
Modellers	4	makers	1
Chasers	8	Draughtsmen	3
Lithographers	2	Merchants	2
Decorators	2	Snuff-makers	2
Platers	4	Mould-makers	1
Engine-fitters	5	Silversmiths	2
Painters	4	Sculptors	2
Upholsterers	5	Button-makers	1
Carvers	5	Tool-makers	1
Builders	2	Cabinet-makers	1
Glass-makers	1	Pattern-makers	1

170

There were, additionally, students under 15
 years of age, and chiefly from schools 77

Profession unaccounted or not specified 10
 ——
 257

Briefly, what two or three things can you deduce from this list?

From the small numbers shown in many of the vocations, the list suggests that close touch was kept with the needs of local manufacturers, and that Birmingham was a city with a vast range of occupations. Clearly, the Fine Arts (painting and sculpture), promoted in other schools of design, play a less important part here. The business side of arts manufacture (merchants and clerks) is taught in something like its natural environment. Some teachers must have taught several subjects, or were brought in part-time, otherwise the school could not have sustained the number of specialists the list suggests.

50 All this design training was applauded less as a necessary part of the new craving for ornamentation than as a step in the right moral, not to say fiscal, direction. It is difficult to spot the humbug in many apparently earnest declarations on behalf of the factory labourer. But often the hypocrisy is clear. Since 'Art' came to the potteries no one, it was said, can fail to notice the great moral and intellectual changes there. Similarly in Coalbrookdale – and wages will 'necessarily' rise. 'Art affords the best antagonistic force to the dementalising and almost demoralising results which are, to some extent, necessarily involved in the excessive division of labour.' (For other comments see Anthology L3).

51 It is hard to tell how genuine such sentiments were. All this talk of an alliance between the artist-designer and the manufacturer was, it seems, prompted in the first place by visions of a great mercantile Britannia dominating the commerce of the world. To achieve that, obviously the quality of the products had to improve, and with it the status of the designer. But it was an illusion to think, as some people did, that it was the artistic tail wagging the mercantile dog. 'We want artists to become the friends and allies of manufacturers, not

their servants', it was said. We want them to become 'partners in educating the people; in improving the tastes and consequently the morals of the community . . .'. It was believed that the stupefying sameness of the mere mechanical operation of a machine, was best mitigated by art in partnership with manufacture. Thus the worker may 'develop his intelligence and exercise his judgement'. Yet a great deal of British manufacture did not involve new design, but as in the textile industry and its Indian calicoes and Paisley shawls, it imitated foreign designs originating in the handicrafts.

A NEW MORALITY: GOOD ART CHEAP

52 The prevailing conviction of the time was that a great contribution was being made to the comfort, the luxury, the knowledge and the morality of mankind. Art should be cheap. 'Art should not be content to minister to the tastes of the few alone . . . but its healthy influence should be felt among THE MILLION . . .' Artists should work not only for THE FEW but for THE MANY, 'who receive a lesson every time they see or touch a common thing which mind has, so to speak, rendered sacred.'

TASTE

53

E might now look at how mind has rendered these objects 'sacred'. In this century one consistent refrain has been sung in derision of the monstrous decorative smörgåsbord which characterised Victorian design. There is I think much truth in the refrain. Certainly sensitive critics at the time admitted readily, if regretfully, its shortcomings. But in the facile remonstrances levelled against the Victorians, one should not become blinded to the positive elements in their design. What fine design of our own time may be overlooked when our future critics lump the lot – good, bad and indifferent – into a single characteristic mode? I've already indicated that nineteenth-century writers on British art and design were quite aware of the excesses of design and the poverty of taste in the flood of trivialities which inevitably surfed in on the great wave of art manufacture.

54 But to stem the tide would have been like trying to hold back the Atlantic ocean with a mop. The editors, for example of the *Journal of Design*, in their first issue (1849), demonstrated their sensitivity to the craving for novelty. Though they saw it as 'a considerable motive power in generating improvement', unduly fostered, they feared, 'it may be pushed to an unhealthy extreme'. Keeping in mind both positive and negative aspects, what, briefly, are your views on this question of *novelty* in design today?

55 Attitudes (and sometimes they become moral views) about product design, tend to polarise around two concepts, stability or innovation:

1 That a good, 'basic' design is timeless, universally relevant, more respectful of function and true to material. That to foster innovation for its own sake, is to reduce design to satisfying mere whim and fashion, and to encourage a kind of competitiveness which is wasteful, degrading and pernicious.

 For stability in design and against innovation

2 The desire for novelty comes from some deep human impulse which craves variation and change. To innovate is to exercise the imagination, to give joy and freedom to the spirit. To establish rules and formulae is to stultify design. There can be no universal standards for taste.

 For constant change and against fixed principles

In considering these two categories, do you think modern design is closer to 1 or to 2?

As you can see, the subject may easily be moved into economic, ethical and philosophical spheres. Whatever view you are inclined to take, I hope you will understand that, despite the kind of polarisation referred to above, this is by no means a 'black and white' issue. Furthermore, if the immediate social and technological environment is taken into consideration – the urban one particularly – we are compelled to think of how the machine and its capacity to produce ornament would lead to a propensity for novelty; novelty and fashion in turn, to heterogeneous styles – and conceits – in ornament, and *that* in its turn to the jading of tastes and inevitably to redundancy and obsolescence – all to be repeated in an irresistible cyclic process.

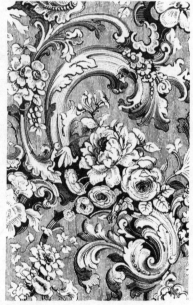

Fig. 29

56 Let's now try a little exercise in taste. Here is a typical carpet design of the period by Pardoe and Hooman of Kidderminster. What do you think of it? What do you like about it? What do you dislike? And what, especially, do you think a discriminating Victorian might have said about it? Note your thoughts briefly in the space below.

57 A distinguished contemporary artist and critic (Richard Redgrave) did, in fact, comment on this kind of design found frequently not only in carpets, but in upholstery fabrics as well. Speaking of carpet design he stressed the word 'utility' and he gives us an interesting insight to his particular meaning for the term. 'UTILITY' was used, not in the obvious sense – that carpets were meant to cover floors. A carpet, he said, was also the ground from which all the furniture and other objects arise.

> It should, therefore, be treated as a flat surface, and have none of those imitations of raised forms or solid architectural ornaments so often seen; the colours should be without violence either in hue or contrast, that they may not intrude upon the eye to the disadvantage of the more important objects placed upon the carpet.

He then goes on to describe carpet designs, both French and English (with the emphasis on the French), in which shells and scrolls coupled with floral bouquets are, he says, entirely out of place. He describes others (referring probably to this one in Fig. 30) in which even landscapes with palm trees must be walked over and which obtrude far too strongly upon one's attention.

Fig. 30 This is the kind of carpet design with flowers, scrolls and palm leaves which Redgrave disliked. It is a Brussels velvet, manufactured by H. Brinton & Sons of Kidderminster, and shown in the Great Exhibition. It was elsewhere praised for 'the infinite variety' of the forms, and for the 'great ingenuity and skill in combining them into an harmonious composition'.

58 You may not agree with him, though his views correspond very much to those held today by people who think about design and good taste. Certainly, it is possible to make out the opposite case. After all, almost any taste can be justified. But it must mean something when even the views of Victorian critics, critics who had strong preferences for ornament, agree with views generally held in this century by a discriminating public. Could it be that in essence, in questions of basic rights and wrongs of design, we are not as cut off from the Victorian past as we'd like to think?

59 The dangers inherent in the unrestrained use of ornament were recognised early. The *Journal of Design* had this to say in 1849:

ON THE MULTITUDE OF NEW PATTERNS

> The love of novelty, strong in most human beings, is the source of great pleasure and a considerable motive power in generating improvement. But it may have its disadvantages, and it is quite possible that, fostered by circumstances unduly, it may be pushed to an unhealthy extreme. We believe that this is the case in all kinds of manufactures at the present time. There is a morbid craving in the public mind for novelty as *mere novelty*, without regard to intrinsic goodness; and all manufacturers, in the present mischievous race for competition, are driven to pander to it. It is not sufficient that each manufacturer produces a few patterns of the best sort every season, they must be generated by the score and by the

hundreds. We know that one of our first potters brought to town last year upwards of a thousand patterns! There are upwards of six thousand patterns for calico-printing registered annually, and this we estimate to be only a third of the number produced. In the spasmodic effort to obtain novelty all kinds of absurdities are committed. The manufacturer in *solid* forms turns ornamental heads into tails and tails into heads, and makes the most incongruous combinations of parts. The manufacturer of fabrics ornamented on the surface cannot be content with harmonious blendings of colour, but is compelled to be most *uncomplimentary* in his colouring. One of the best cotton-printers told us that the creation of new patterns was an endless stream. The very instant his hundred new patterns were out he began to engrave others. His designers were worked like millhorses. We are most decidedly of opinion that this course is generally detrimental to the advance of ornamental design, to the growth of public taste, and to the commercial interests of the manufacturer and designer. We also believe that the rage for novelty is the main support of the piratical designer. The means of checking the evil are not very obvious or direct, but we are convinced that something may be done. A better copyright law is one means. Copyright should be longer, whereby the property value in design would be increased, and the means of protecting this property should be also increased and simplified. The public has to be taught to appreciate the best designs. Exhibitions of manufactures and good criticisms of them assist in this direction. We trust our own labours will be found, with the help of the best manufacturers also, to aid in curbing this restless appetite for novelty, which is so generally mischievous.

We would impress upon manufacturers who may be disposed to exhibit their new patterns in THE JOURNAL OF DESIGN, and also upon our readers generally, that we desire to exhibit and criticise not so much the best and most costly productions, and therefore exclusive patterns, but the *fair average* character of our manufactures, not neglecting the *very cheapest*. With this view we have not hesitated to insert some of the simplest in this, our first number, and among them a specimen of the very cheapest kind of paper-hanging. Even this is a piece of decoration beyond the reach and enjoyment of too many. We have already pointed out that the actual patterns must necessarily be small: smaller than those in which manufacturers necessarily prefer to exhibit their works. The cost alone of the patterns is a sufficient reason for their comparative smallness. But we are sure our readers will acknowledge that the very *smallest* is better than *any* kind of substitute, and we shall take care that the pattern always represents duly what we wish to enforce.

The season for new patterns will be in full activity in the course of the middle of April, and we beg leave to call the special attention of manufacturers to the notice at the beginning of THE JOURNAL OF DESIGN.

60 Here is a contemporary, speaking in 1847 of the recurring incongruities to be found in design: 'We see the Gothic mixed at random with the Grecian; the Elizabethan, the French of the period of Louis XIV and the Flemish with the Roman, the Moorish and the Egyptian; and all these overlaid with a variety of ornament invented for the occasion to hide these glaring errors.' (from the *Tradesman's Book of Ornamental Designs*).

EXERCISE

These six objects, all British, were made between 1845 and 1851. Each has at least one distinct feature about it which very likely would have been found objectionable to contemporary critics like

those who wrote in the *Journal of Design*. Can you find one element in the design of each which might have been criticised at the time? Note them in the boxes provided if you like.

Fig. 31 is a silver pitcher.

Fig. 32 is a teapot.

Fig. 34 is a gas jet.

Fig. 33 is a bell.

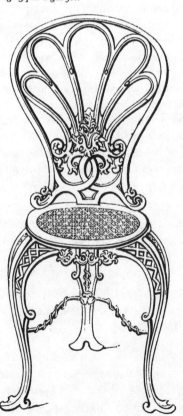

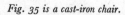

Fig. 35 is a cast-iron chair.

Fig. 36 is a cup.

pitcher

teapot

bell

gas jet

chair

cup

DISCUSSION

Fig. 31 The pitcher would have been thought inappropriate by critics because its ornament was there more to tell a story than to enhance the form. Its decorative motifs would have been thought too diverse, and the animal's legs at the base, the beast itself apparently crushed by the weight of the object, do not make a convincing pedestal. Its Roman prototypes are much more convincing.

Fig. 32 The main objection to the teapot would be an aesthetic one: those tiny feet do not visually support the massive body.

Fig. 33 A bell made of leaves doesn't really make sense, the foliated forms being rather far removed from the normal function of that object.

Fig. 34 This gas jet was criticised because the ornament itself is substituted for the thing to be ornamented. And who ever heard of a flower which emits a flame?

Look at these three examples of gas jets from the same period. One might object to the first two as being a bit frivolous, but the function of the object, in all cases, is made clear. In the last, particularly (Fig. 39), the consistency of form and the elegance of the curves would meet with approval.

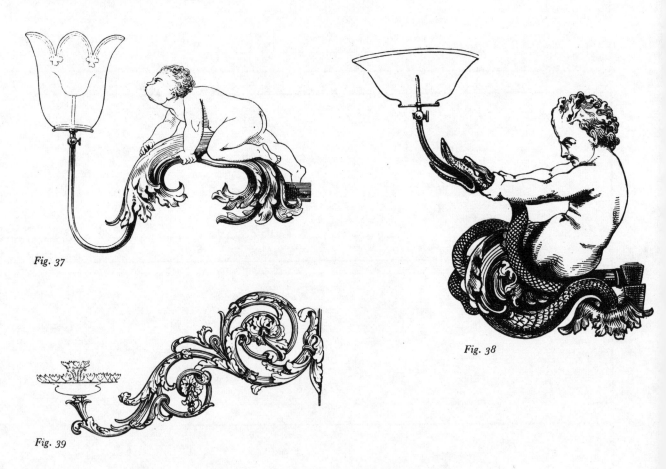

Fig. 37

Fig. 38

Fig. 39

Fig. 35 This cast-iron chair, manufactured by the Coalbrookdale Company, was called 'perverse'. An intense dislike was shown for the idea of a three-legged chair because, with a single leg at the back, it was both physically and visually unstable. Cast iron imitating bamboo, as it does here, was

ridiculed. The chair, in fact, was also painted to simulate further the appearance of bamboo. Criticism was not always consistent (see Fig. 21).

Fig. 36 A cast-iron cup, meant to hold liquid, is rendered as a basket – hardly appropriate. Based on Roman terra-cotta prototypes, little argument, I think, could be raised against the form and character of the pedestal.

Three of these examples (Figs. 33, 34, 36) are illustrated in *Analysis of Ornament* (1856 etc.) by Ralph N. Wornum, distinguished and popular lecturer in Design at the Government School of Design, Somerset House. They were first used in his lectures, 1848–50. The violation of a natural form, when applied to uses with which it has, intrinsically, no affinity, is to commit, says Wornum (who was normally genial and mild) an outrage and to produce 'aesthetic monstrosities – ornamental abominations'.

Do you think most of the objects illustrated in Figs. 31–36 would be considered objectionable when applied *in principle* to design today? I do.

61 Still, in our century the Surrealists in their sculpture, painting and made-up objects saw a virtue in incongruity and heterogeneity. Many of them may well have favoured carpets with palm trees and those conglomerate fantasies of Victorian design. How is it, do you think, that tastes can differ so widely? Are there no standards then that can absolutely determine the excellence of art?

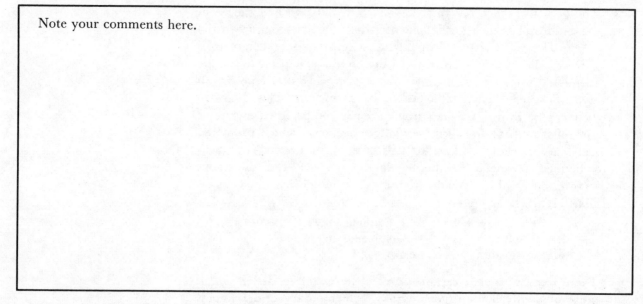

Note your comments here.

62 *Chacun à son goût* (everyone to his own taste). An apt, but not entirely impeccable observation of the French. You may remember in the *Introduction to Art* (Unit 11) the discussion of the ways in which taste is formed. Much of that is appropriate here. Taste is formed by what people *see*; the range of taste limited by what is available. Does this mean that there are no objective rules, and that in essence taste is just a lot of *ad hoc* preferences? Artists and designers *have*, within definable cultural contexts, arrived at rules for colour, composition, proportion, etc., which amount to standards by which 'taste' could reasonably be measured. This was especially so in 'monolithic' cultures (homogeneous and well-integrated), like those of ancient Egypt, China, Mediaeval Europe, and in most primitive societies. The difficulty arose (and this is particularly true of the

early part of our own century) when artists tried to establish fixed, immutable and *universal* laws (N.B. Kandinsky, Unit 12) which were believed to be applicable in all times and in all places, or even in their own time and place. It is sometimes thought that this desire to set up universal laws for art is compensatory, and due to the dissolution of traditional styles and what is called the 'devaluation of symbols'. Try to recall your views when writing the assignment essay on the possibility of a 'language' of colour in Unit 12. They may well apply again here in this question about standards of taste.

63 What is to be expected when, in the 1840s, despite the qualifications, even the canons of *good taste* encouraged both the ornate *and* the eclectic – a combination guaranteed to spell trouble? Here is an example of how a designer was then instructed: 'We may range from the days of Ptolemy to those of George the Second, taking here and there a bit or scrap of pattern or ornament, a Greek vase, a Roman tripod, a British urn or a Saxon ornament, just as the case may warrant; and endeavouring from such varied materials to deduce some useful hints to pattern designers and manufacturers.' And yet this startling piece of advice is followed by the warning that overloaded ornament and revelling in the 'monstrous and absurd' is not the most desirable principle of modern design. Well, pity the poor designer who is damned if he does and damned if he doesn't. And what might further surprise you is that both comments come from the same magazine, the *Art-Union*, and appear in its pages in the same year (1847).

64 The debt to France must not be overlooked. Large and successful exhibitions of French goods had been held in that country in the 1840s. They often featured in English magazines. The commercial success of French products tempted British manufacturers to imitate them. But some critics, hoping for the emergence of a true British style, believed French influence to be pernicious. This desire to 'deliver' the British designers from 'Frenchness' persisted as late as the 1880s and the so-called 'aesthetic movement' which promoted simplicity, sincerity, and art for art's sake. When Oscar Wilde, self-appointed spokesman for the new 'aesthetic', delivered his famous lectures on English art and design in 1882, he mocked the ostentatious French style:

> . . . the gaudy, gilt furniture writhing under a sense of its own horror and ugliness, with a nymph smirking at every angle and a dragon mouthing on every claw.

65 There were, of course, certain extremes in Victorian design which quite obviously flouted 'good taste'. Contemporary critics found, for example, a disagreeable lack of respect for antiquity in such stylish items as a couple dancing the polka on the capital of a Corinthian column. How is one to respond to such works? Are they to be condemned for their crudity or applauded for their vivacity and freedom of spirit? It was elegance of form and design that was sought – and imagination too. The frescos of Pompeii and Herculaneum were much admired and often used in Victorian design: Dolphins, winged godesses, the Egyptian asp, the ichneumon and the butterfly and a large variety of plant forms: laurel wreaths, ivy, the water lily and the honeysuckle. It wasn't simply that the art of the past was used which irked critics in the Victorian era, but that it was abused. Its handwriting was only copied, its real significance misunderstood, and 'mechanical travesties' were made of its bold

ichneumon: a mongoose-like animal believed by the ancient Egyptians to devour the eggs of crocodiles

or fluent, easy or direct forms, all in the haste to make money. Undue liberties of design were succinctly parodied in the *Art-Union* in 1846, in this piece taken from the opening of Horace's *Ars Poetica*:

Suppose a painter, to a human head
Should join a horse's neck, and wildly spread
The various plumage of the feathered kind
O'er limbs of different beasts, absurdly joined;
Or if he gave to view a beauteous maid,
Above the waist with every charm arrayed,
Should a foul fish her lower parts enfold
Would you not laugh such pictures to behold?
Such is the thing that, like a sick man's dreams
Varies all forms, and mingles all extremes.

Fig. 40

From antiquity, the 'grotesque' had a long and rather respectable lineage in art, though more perhaps on the fringes than at the centre. The Victorians had the machine and all the history books, and in pilfering the designs of ages past they managed, though unwittingly and by default, to shift the grotesque from the domain of the aesthete and the voluptuary, to that of the ordinary man.

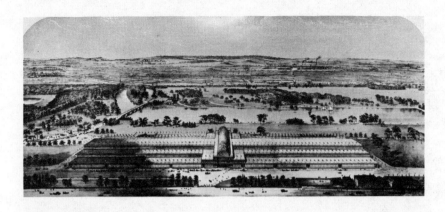

Fig. 41

66 THINK you will agree that the great feeling of strength, not to mention the moral impetus given by the happy conjunction of Art and Manufacture, would almost inevitably lead to an international demonstration of the presumed superiority of British design (the idea, as you know, had been advanced by the *Art-Union* in 1848). The fascinating and detailed story of the erection of the Crystal Palace, of the objects shown there, and of all the hectic events surrounding them, has been engagingly told in several previous publications, a few of which are referred to in this text.

67 My purpose here is first, to discuss the popular reaction to The Exhibition, referring to typical documents of the less official kind which, I believe, though little explored, light up yet another facet of this extravagant undertaking. Second, I'd like to describe to you, in a brief and general way, the astounding feat of the erection of that fabulous Palace of iron and glass. (The use of iron in architecture and design has been enlarged upon in Tim Benton's television programme, *Cast Iron in Architecture*, which supplements this Unit). Third, in this section, I should like to acquaint you, again briefly, with the Exhibition itself: with the objects displayed and, in some degree, with the reactions of critics.

THE TREES IN THE TRANSEPT

68 HE meaning of the whole idea of the Crystal Palace, or of the Great Exhibition itself could not be better symbolised than by what was called 'The Battle of the Elms'. During the initial stages in the planning for a building to house the exhibits it became expedient to demolish about ten trees which would be in the way.

69 An outcry arose, especially from those who had serious misgivings about the ultimate value of the Exhibition. The more sensitive among them had a presentiment of trouble to come, of the possible contradiction between technological advance and human betterment. They already knew from past experience that industry and the machine had more often increased, rather than mitigated, the misery of the human condition. Some saw, symbolically, in the destruction of the trees the

ALBERT! SPARE THOSE TREES.

Fig. 42 Albert! spare those trees. From Punch (June 1850).

conflict between the Juggernaut of industrialism and natural beauty and the simple life. Others, more politically and socially obtuse, and with personal axes to grind, let loose all their xenophobic instincts once a vision formed of this island being 'invaded' by hordes of foreigners (see Anthology K6).

70 Unfortunately for the supporters of the Exhibition, the notoriety went to a most unremittingly chauvinistic member of Parliament, Colonel Charles de Laet Waldo Sibthorp, a congenital reactionary and vociferous champion of isolationism and enemy of Free Trade.

71 The issue of the trees was crucial. Great fears were expressed about the type of building which might be erected. Apart from the inevitability of nuisance in that choice area of Hyde Park (south of the Serpentine), any building of permanent material, it was feared, despite the assurances given by the Exhibition Committee, would be there to stay. The well-to-do people of Knightsbridge and Kensington Gore were dismayed at the callousness of the Committee. The matter was much debated in Parliament and discussed in *The Times*. Petitions were signed. Alternatives were offered: the London Bridge area, the north bank of the Regent's Canal to its city basin, Battersea Park, the Isle of Dogs. Anywhere but in that exclusive residential section of London.

DESIGNS FOR THE BUILDING

72 But very likely in the minds of the Committee the Exhibition needed the panache of Hyde Park and the refinement and affluence of the area. It was decided to hold an open competition for the building design. The requirements of the Building Committee were published in March 1850, and though neither materials to be used nor structural principles were specified (other than that the materials had simply to be fireproof and the light had to come from the roof), the preservation of the trees was made explicit. The competitors had barely more than a month to submit their designs.

73 Of the 233 designs sent in (195 British; 38 foreign), several, it so happened, were conceived largely as iron and glass structures. Some of these, like the Crystal Palace itself, were based more or less

on modular systems (i.e. standardised building units to facilitate construction and keep costs low). Many of the designs, whether calling for quantities of iron and glass, or for other materials, were very impressive. Nothing in the Committee's requirements specified a building which might easily be dismantled, nor in any way was a temporary structure suggested.

74 In two reports of the Committe to the Royal Commission (9 and 16 May), William Cubitt, its Chairman, lavished praise upon the designs received.

> Our illustrious continental neighbours have especially distinguished themselves by compositions of the utmost taste and learning . . . exhibiting features of grandeur, arrangement, and grace which your Committee have not failed to appreciate.

In the Reports he spoke admiringly of the 'practical character' of the British competitors, especially suitable to the temporary purposes of the building (that qualification mentioned here for the first time), and to its cost. In these designs,

> The principle of suspension has been applied in a single tent of iron sheeting, covering an area averaging 2200 feet by 400 feet by a lengthened ridge, or in separate tents on isolated supports. Others display the solution of this problem by the chapter-house principle, and a few by the umbrella or circular locomotive engine-house system of railway-stations, either with a central column or groups of columns sustaining domes or roofs to the extent of four hundred feet diameter.

It is clear that many of the competitors, insufficiently briefed perhaps, set beauty above expense: 'They have indulged their imaginations', Cubitt remarked, referring to 'inspiring' buildings based on the Egyptian hypostyle, the Roman thermae, Arabian and Saracenic prototypes. The designs submitted by M. Hector Horeau (Paris) and Messrs. R. & T. Turner (Dublin) were given special mention for their 'most daring and ingenious disposition and construction' (Figs. 43 and 44).

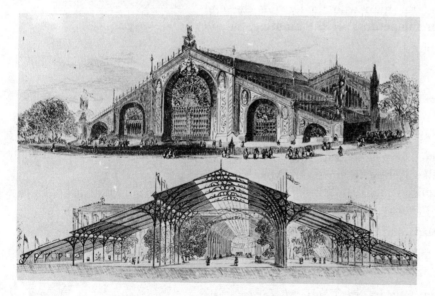

Fig. 43 Hector Horeau. Design for Great Exhibition building, 1850 (exterior and interior views). The structure was to be made entirely of iron with no wood used at all. The façade was to consist of sheet metal, porcelain and glass. The roof glass frosted with ornamental patterns. Horeau was the architect of Les Halles, the famous central market place of Paris, soon to be demolished, the area scheduled for redevelopment in the 1970s.

75 But after all the commendations were dispensed, Cubitt rather flatly announced that the Committee had been unable to select any of the designs. None combined *all* the features considered essential. Though this, as you can guess, did not pass unchallenged, the

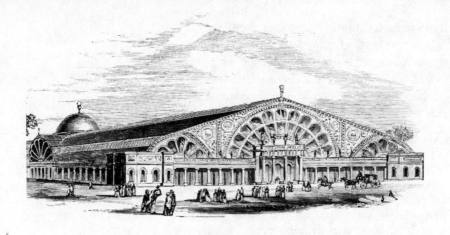

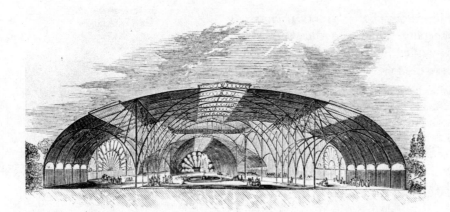

Committee had, in fact, reserved the right, if no single design were chosen, to produce a building of their own, using, if necessary, elements from any of the designs in the competition. Objects of all kind, to be included in the Exhibition, were beginning to arrive. Time was getting short. The Committee, having announced its intentions, immediately proceeded to design their own structure. At this point, enter Paxton.

76 The name of Joseph Paxton, the man who finally 'got the job', does not appear in the list of competitors for the building. Briefly, the story from that time is this:

c. 7 June	Paxton gets wind of the Committee's cumbersome design.
11 June	Paxton produces his famous sketch of an iron and glass building on a piece of blotting paper.
20 June	Paxton completes first plans and with help of influential friends like Robert Stephenson (Member both of Royal Commission and Building Committee) discusses them
21–22 June	with Prince Albert and members of the Committee.
22 June	Building Committee design published in *Illustrated London News*.
6 July	Paxton's design appears in *Illustrated London News* receiving much public support.
10 July	Tenders out for the erection of building.
15 July	With some modifications, Building Committee accept Paxton's design.

16 July Tender of firm of Fox and Henderson for erection of
 Paxton's building accepted.

It is clearly a case of Paxton to the rescue, and though the whole operation may appear to have something 'fishy' about it, Paxton seemed to be, in fact proved to be, in all ways a most expedient choice.

77 The campaign to save the trees continued unabated, despite the Building Committee's assurances. Several had already been destroyed, and it looked as if the vandalism was to be complete with the destruction of the others. In hopes of placating the cantankerous Colonel and his supporters, the Committee had little choice but to induce Paxton to re-design his building to enclose three giant elms. An arched transept, 108 ft. high, was the answer, as you can see in the illustration below. The trees were completely enveloped – as in a gigantic conservatory. For many supporters of the Exhibition, defeat had its compensations. Instead of the rather ordinary, flat-roofed structure originally proposed by Paxton, the rising curve of the transept was considered more elegant and preferable. From that time those trees were known as 'Sibthorp's Elms'.

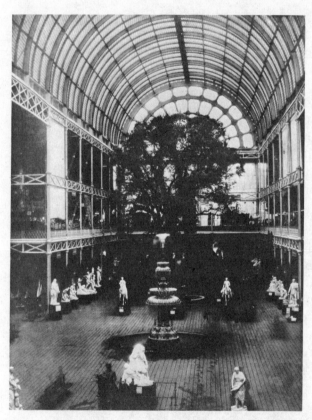

Fig. 45 Photograph taken in 1851 showing the transept of the Crystal Palace enclosing one of the giant elms.

78 The compromise of the Exhibition Committee was celebrated in a sentimental poem by the comedian Julio Henry Hughes:

> The nave in its perspective endlessness,
> Or the fair transept with its broad roof curled
> O'er-arching highest Trees, therein preserved
> Because the people willed it! To all time
> This circumstance should be recorded, served
> To show a Nation's wish was not a crime
> To be resisted and subdued, but soon
> As formed was gracefully conceded by
> Authority, nor yielded as a boon,
> But recognized a right; ''twas Liberty'.

79 The organisers of the Exhibition had reason however to regret their capitulation. Because of the trees the building was invaded by sparrows, those birds depositing an undesirable patina on the exhibits as they were unpacked from their cases. Perhaps one of the last great tactical strokes of the Duke of Wellington who revelled in the Exhibition (he died in the following year), was his advice to the worried Queen: 'Try sparrow hawks, ma'am'. They did, presumably, and it worked.

PRIDE IN THE EXHIBITION

80 A large and well-intentioned section of the public saw in the Exhibition the promise of a bountiful and glorious future not only for Britain but for humanity itself. This joy in man's industrial and technological achievement is conveyed by the Consort, Prince Albert, in a eulogy to progress made in the heat of preparations for the Great Exhibition. We are living, he said, in a most wonderful period of transition. History itself points to its great end, 'the realisation of the unity of mankind'. The 'moving power' of civilisation is 'the great principle of division of labour'. (See Anthology K2 for Albert's address at the Opening of the Exhibition.)

81 Queen Victoria, too, an avid attender of the Exhibition, renders ecstatic accounts of it in her diaries (see her reply to Albert in the Anthology). To many Victorians the Crystal Palace must have appeared as a magnificent affirmation of industrial prowess in which high moral purpose and mercantile proficiency were symbolically united. *The Times*, as an example, having come round from its previous position of antagonism was now transported with delight at the glorious spectacle of the opening. With jubilation it declared that above the crowds 'rose a glittering arch far more lofty and spacious than the vaults of even our noblest Cathedrals . . .'

82 No doubt prompted by the editors of the *Art-Union*, the idea for the Exhibition had been given shape in 1849 by an enterprising group of men. Two of them, Prince Albert and Henry Cole, had collaborated earlier in the Royal Society of Arts. They had been responsible for three successful exhibitions of industrial design since 1847 – though these were comparatively small and confined to British exhibitors. Venerated as an act of true community, the Great Exhibition was nevertheless a cunning instrument of commercial enterprise. Joseph Paxton, the architect of that magnificent structure, saw it as a means of cementing the nations of the world into a great brotherhood. Albert saw it as a divine instrument in the fulfilment of a great and sacred mission of peace and love.

THE POPULARISATION OF THE EXHIBITION

83 VAST amount of printed commentary accompanied the preparations for the Great Exhibition, and continued unabated until well after the event was over. Sermons by the score were preached up and down the land, most of them hosannas to the high-mindedness of the enterprise. At a time when much of Europe trembled on the brink of disaster, the Great Exhibition was hailed as an augury of good,

as a means of helping onward the triumphal reign of peace –
an opportunity to promote the glory of God, the wonder and
enlightenment of the age, a temple of concord.

84 Yet for some it was a recrudescence of Belshazzar's Babylon. It was
called 'The Great Humbug of 1851', and claimed to be nothing
other than a conspiracy of manufacturers.

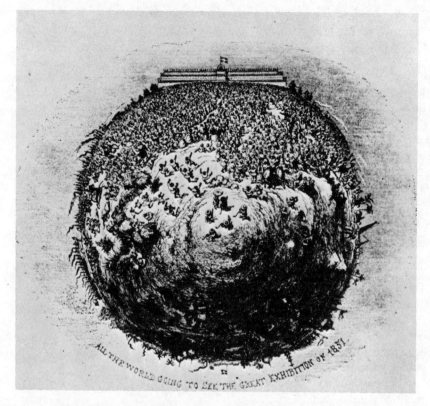

*Fig. 46 All the World going to see the
Great Exhibition of 1851. Drawn and
etched by George Cruikshank.*

85 A great number of religious tracts poured from the presses of
Paternoster Row, riding high on the carnival euphoria of the day,
coming up with some very droll analogies between the Exhibition,
the Bible, and the teachings of Christ. In the philanthropic cast of
the Exhibition they saw an emanation of 'that sacred and inspired
volume' – and to some extent they were right. Fly-sheets posted
conspicuously in the Palace itself contained, among other messages
of benevolence, the succinct phrase, a title to a poem, which rings
familiar to our ears today, 'Love versus War'.

86 The world of Commerce was not slow to show its enthusiasm, an
example of which can be found in the poem embossed on Vulcanised
India Rubber and distributed widely by Charles Macintosh and
Company:

> The band of Commerce was design'd
> T' associate all the branches of mankind;
> And, if a boundless plenty be the robe,
> Trade is the golden girdle of the globe.

87 Poets, too, added their rhapsodic mites to the general ebullience.
Among the many titles were included: 'Ode on the Great Exhibition';
'The House that Albert Built'; 'Love and Loyalty'; 'Dedicated';
'Commerce'; and 'Sovereign of All'. Here is an example, typical I
think, of the popular indulgence in sentimentality over the Great
Exhibition:

Celestial Peace the plan designed,
 Her snow-white banner she unfurled;
Love oped the gates to all mankind,
 And hailed the workmen of the world.

And, indeed, clubs of working men at Bradford, as an example, were by May 1850, already investing their savings in view of a holiday to the Exhibition a year later.

88 William Makepeace Thackeray, true to his middle name, lavished praise on the venture with a long May-Day Ode which begins:

But yesterday a naked sod
 The dandies sneered from Rotten Row,
 And cantered o'er it to and fro:
 And see 'tis done!
As though 'twere by a wizard's rod
 A blazing arch of lucid glass
 Leaps like a fountain from the grass
 To meet the sun!

And also with his amusing but informative 'Mr. Molony's Account of the Crystal Palace' (see Anthology K3).

89 There was, however, no slacking among the satirists:

It is a glorious sight, when all may see
Assembled nations as one man agree;
But much I fear the bond of this great farce
Is just as frail as its component glass.
No doubt they'll come, in countless numbers too,
For they've one common object, gain, in view.
And even Moses with his bard in pay,
Can't match the advertisement of the day.
But as for doing good to English trade,
I think a slight mistake therein is made;
These foreign gentry sell, but are not sold,
And lack, not English goods, but English gold.

90 Fairy tales, composed for children of all ages, told of the Paradise to come:

'The Enchanted Hive; or, the Island of the Bees.'

But the Island of the Bees had now become the most powerful of all the world! and the good fairies, Industry, Art and Science, had so spread their powerful influence over all the Island, and, indeed, the whole Universe, that the good queen and her consort resolved to do honour to the fairies, by establishing a gala in their dominions, and inviting the industrious bees of all nations to send their products to this great fête.

91 Learned essays were produced in large quantities excogitating on the probable influence of the Exhibition upon labour and commerce and on the advantages to be gained by working men attending it. (Note Henry Mayhew's views on this. Anthology K5.)

92 Music and popular street ballads contributed to the hullaballoo. Their titles convey the enthusiasm of the time:

Crystal Palace Waltz; Crystal Palace Polka; England's Merry Polka; Grand Exposition Quadrille; The New Palace of Aladdin; The Temple of Peace; Meeting of the Nations; Hymn of Praise for all Nations.

And the street songs:

Crystal Palace; The big show coming and more again; Have you been to the Crystal Palace?; Come let us go and see the Exhibition for a shilling.

93 Notwithstanding the sober attitude, in some quarters, that that great functionalist aviary was a kind of vacuum encasing a triviality, the larger public warmed to the idea. Once the initial antagonisms were overcome, the response was one of immense approbation, and is typified by this verse:

> And now a prayer sincere
> For him whose genius brought such wonders here.
> God kindly grant to Albert health and peace,
> Whilst public and domestic good increase.
> May he behold his children rise in mind
> To wisdom turned! Their little hearts as kind
> As is his own! An honour to his name,
> Which to remotest time this Palace shall proclaim!

BACKGROUND

94 THOUGH the Great Exhibition was its own generating force, one must try also to understand a few of the possible underlying reasons for the self-congratulatory, almost self-hypnotic spirit in which its advocates pursued their cause. The Exhibition was conceived in 1848, the planning began in 1849 just as France had been plunged into revolutionary turmoil. Marx's *Communist Manifesto* was published in 1848. Britain was not without its political and social complications. A Papal decision to re-establish Roman Catholic dioceses in England produced sharp and hostile reactions from Protestants. All was not sweetness and light. But to some extent the problems of religion and politics were tucked nicely out of sight. So, too, the conditions of the labouring classes (see Anthology B3, C5, F10). For a moment in history the Crystal Palace helped an entire population to shift its focus away from its troubles to the promise of Kingdom Come. And the proliferating means of popular communication (the *Illustrated London News*,[1] as an example, first appeared in May 1842) assisted by the reduction, in 1850, of the stamp duty, and its abolition in 1855, helped considerably in spreading the salve.

95 This was to be no ordinary event. The scale of the operation is staggering. Small trade fairs and exhibitions of manufactured products we know had been held before. But never had they been so purposefully international in scope. Nor were they ever conceived in such monumental dimensions. 'The Great Exhibition of the Works of Industry of all Nations in 1851' – the full and proper title – was the progenitor of all those international 'Expos' in Europe and America which followed regularly thereafter.

1 The circulation figure for the I.L.N. was then 24,000 per week, and by December that year it had climbed steadily to over 60,000. In 1851, at the time of the Great Exhibition, partly because it consistently gave coverage to it, 130,000 copies per week were being sold, and the number increased after that.

96 The 'Palace' itself was a miracle of construction. Joseph Paxton, a brilliant polymath, could provide a model for the 'local boy who makes good'. He was a paragon of the self-made man; someone right out of Sam Smiles. Much has been written about the origins of Paxton's design which superseded those submitted in the competition. An excellent source for Paxton is, George F. Chadwick: *The Works of Sir Joseph Paxton 1803–1865* (1961).

97 Chadwick describes Paxton's active life as gardener and factotum to the Duke of Devonshire. Paxton was the designer at Chatsworth of the Orchid Houses (1834), the Great Conservatory (1836–40), and the Lily House (1849) for the gigantic Victoria Regia lily, which he brought to England. Paxton's horticultural enterprises, his landscape work (parks, gardens, suburban layouts) are also discussed in some detail by Chadwick. Paxton's precocity in solving architectural problems, especially as they pertained to iron and glass construction, is examined. Some of his innovations, dating from the early 1830s, such as a special wooden sash-bar for glass on flat roofs, were influential on early railway station design, and ultimately on the Crystal Palace. One type of gutter, light and strong, solved the problem of collecting rainwater on the outside, and condensation on the inside of glass buildings – that again becoming almost indispensable later to the Crystal Palace (Figs. 47–49). Paxton was well ahead of his time in the techniques of erection of wide-span structures.

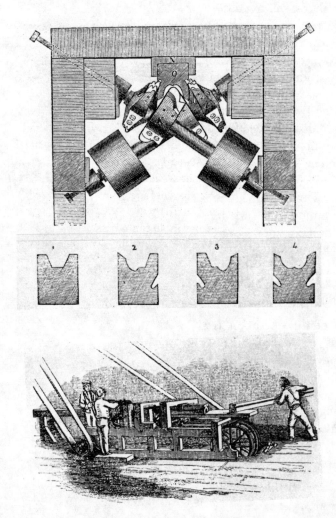

The construction of Paxton's wooden gutters. Fig. 47 shows the section of the gutter, O, acted upon by separate cutters. 2,000 feet per day were produced by this machine, the required 20 miles of gutter turned out in 2 months. Fig. 48 shows stages in cutting the channels. It would have taken 300 men employed the same length of time, to do the work of this single machine. Fig. 49 shows construction details of a 72-foot truss which spanned the nave. The gutter, B, and the roofing glass are in place.

Fig. 48

Fig. 49

98 An important point is made by Chadwick in discussing Paxton's antecedents; not to belittle Paxton's remarkable achievements and great organisational abilities, but, as I interpret it, to show that ideas are cumulative, and interchangeable, and great ones do not come out of thin air or empty heads. *Of course* there were precursors in iron and glass buildings. Those discussed by J. C. Loudon, for example, in his *Remarks on the Construction of Hot Houses* (1817), and in his *Gardener's Magazine*, first published in 1826. Paxton may well have been influenced by iron and glass structures seen in Paris; in the Jardin des Plantes (1833), or the covered galleries of the boulevards and the Palais Royal. There may well have been some useful feedback to him from his own influences on railway station structures in the '30s. As to the idea of *prefabricated* iron structures, these were certainly known before the Crystal Palace. Prefabricated cast-iron house frames for domestic use had been sent to Africa and the Colonies by 1846. It was also suggested at the time that easily assembled and dismantled frames for school buildings could be made cheaply of iron.

Note the John Cragg Churches referred to in the television programme on cast iron

PAXTON'S 'PALACE' OR, 'THE HOUSE THAT FOX BUILT'

99 HE problems of housing an exhibition of such great size confronted the organisers. The Crystal Palace was to contain examples of the accumulated industrial artefacts of an entire civilisation. It was to display the raw materials from which they were made. It had on view the machinery which spawned them. Size, then, was a major consideration. Time was too. The whole project, from the raising of the first column to its completion, miraculously *took less than six months* – and not always under ideal conditions. The building was 1,848 or 1,851 ft. long (the figures vary), 408 ft. wide, and it covered 19 acres (about 773,000 sq. ft.). The length of the galleries alone was almost one mile. The total cubic capacity of the building was 33,000,000 cu. ft. The figures are prodigious: about 202 miles of sash-bars; 900,000 ft. of glass. The weight of the iron used in the building came to about 4,000 tons. Surprisingly, the wood used greatly exceeded, in weight, the iron. The interior decoration, under the direction of Owen Jones, a member of the

Committee and one of the editors of the *Journal of Design*, was
described as beautifully colourful, the ironwork painted in red,
yellow and deep blue combinations, based on laws of colour first
conceived and written about by an eminent French chemist,
Eugène Chevreul, in 1828 and 1839 (see colour plates III and IV).

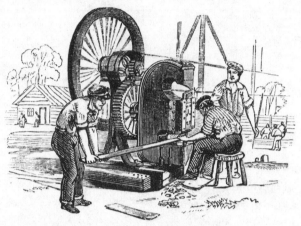

Fig. 50

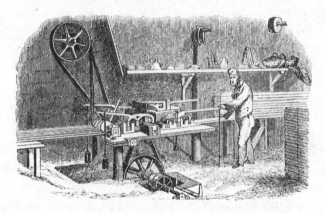

Fig. 52

Fig. 51

Some of the steam-driven machinery used on
the site in building the Crystal Palace. Figs. 50
and 51 represent powerful metal punching,
drilling and shearing machines. Fig. 52
shows a machine for grooving and bevelling
sash-bars which supported the ridge of the
roof and held the glass. Fig. 53, the next stage
in fabrication, shows the sash-bars being
drilled. They were then moved to a machine
which painted them at ten times the rate if
done by hand. 202 miles of sash-bar went into
the building.

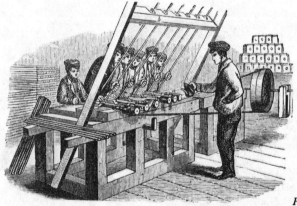

Fig. 53

100 To get that gigantic hothouse up and covered meant new methods
of prefabrication and modular construction which anticipated
twentieth-century construction techniques. The building was
actually erected by the firm of Fox and Henderson, both of whom
were instrumental in carrying out the engineering details conceived
by Paxton, not to mention some innovations of their own. Every-
thing possible was standardised. Ingenious procedures for structural
testing were carried out on the site. And sometimes more empirical
means were employed, such as calling in troops from the nearby
Knightsbridge barracks and having them test the strength of

gallery floors by marching in formation over prototypes. Wagons full of cannonballs were rolled on the floors, and to prove that they were safe, Fox, it is said, even offered to run a railway locomotive over them. For a brief moment in November 1850 the project seemed in danger due to a strike of the glaziers, but the Committee was undeterred; new hands were immediately taken on in their place. Perhaps the most attractive feature of the design to the critics already mentioned was that it could be dismantled with relative ease.

101 At the expiry of the Exhibition, it was suggested by Hamilton Fish, Governor of New York State, by the Mayor of New York City and other American officials, that the whole building be transferred to the States. There was much discussion about what was to be done with it. Perhaps the most enterprising plan, suggested in May 1852, by an architect named Burton, was that it be converted into a tower, 1,000 ft. high, with vertical lifts powered by steam – much higher than, but not unlike our own GPO tower in London.

Fig. 54 Design for converting the Crystal Palace into a tower, 1,000 feet high. The base of the building was to be used as a conservatory; the summit, 70 feet in diameter, for astronomical research, and the remainder for the exhibition of scientific collections. The total floor space would have come to 477,630 square feet.

The Crystal Palace was in fact removed to Sydenham only a few years later and subsequently altered. In 1936, it was destroyed by fire.

JOHN RUSKIN AND THE CRYSTAL PALACE

102 As we already know, not everyone hailed the Crystal Palace as one of the wonders of the modern world. Gloomy prophecies gleefully warned that the wind would blow it down, that the vibrations of thousands of feet would shake it down, that the iron would expand when the sun was hottest and cause it to collapse. But the building

55

stood. Among its most indomitable detractors was John Ruskin. Ruskin was, with hardly a doubt, the most powerful and influential writer on art ever to appear. He hated the Palace and what it represented. The opprobrium with which he regarded it sprang from his fears for art and the mechanisation of man. When, having been moved to Sydenham in 1854, the Crystal Palace was re-opened there with fresh fanfare, Ruskin felt obliged to comment on it. And this he does in his dry, facetious and most scathing style.

103 *I would now like you to read the extract from Ruskin ('The Opening of the Crystal Palace') contained in the Anthology. Then think carefully about the following questions:*

 1 *What do you think Ruskin's real purpose was in writing this essay?*

 2 *Why was Ruskin against the restoration of earlier works of architecture?*

 3 *Why do you think Ruskin was so fearful of changing the physical environment and so adamant about preserving the monuments of the past?*

 4 *For what habits of taste does he berate his contemporaries?*

 5 *What was the 'evil which is being wrought by this age' of which Ruskin speaks?*

THE EXHIBITION ITSELF

Study the floor plan provided here

104 The Crystal Palace was divided into two wings, one for Great Britain and the Empire, the other for all other countries. Every machine in use at the time was on display, many of them in operation (see plate IV and Figs. 55–58). The widest variety of raw materials, and the goods made from them, were shown. The sheer inventiveness of many of the objects on view met with open delight. The whole gave tangible evidence of the confidence, the skill and the energy galvanised by modern industrialism.

Fig. 55 *McNaught's Patent Double Cylinder Steam engine.*

Fig. 56 *Side view of the great hydraulic press used in raising the Britannia Tubular Bridge. Made of wrought and cast iron by the Bank Quay Foundry, Warrington. The press was capable of lifting 2,000 tons.*

Fig. 57 Hick's Hydraulic Press, manufactured in Bolton. It could exert up to 2,500 tons pressure. The hydrostatic press was invented in 1796.

Fig. 58 Hornsby's Steam engine shown in the Great Exhibition.

105 Into this repository were thrown the so-called 'industrial classes' and countrymen of Britain. Some manufacturers even paid for their men to attend, seeing the Exhibition as an instrument of their edification. They came in droves, some perhaps out of curiosity, others certainly in response to the campaign of support mounted by the press. In five and a half months over six million visitors attended. Almost nine-tenths of them payed the lowest admission fee on 'shilling days' (see Mayhew, Anthology K5). Cartoonists delighted in showing the country bumpkin shuffling his way through the Exhibition, ogling this strange new world come suddenly upon him. Other commentators on the daily scene inside the Exhibition note with pride how well-behaved the lower classes were.

106 One way in which design skill could be asserted was to endow the object with a variety of functions. Many of the more than 100,000 items exhibited in the Crystal Palace performed more than one service. Their designers, often, were extremely clever and versatile. But they did not have much of a utilitarian look about them. They were mainly demonstration pieces, and amusing or astounding though they appeared, it is doubtful that they were commercially viable. Of course, as advertisement for their sponsors, they may have been effective. But to some extent they are bound to distort the true character of the manufactured goods at the time.

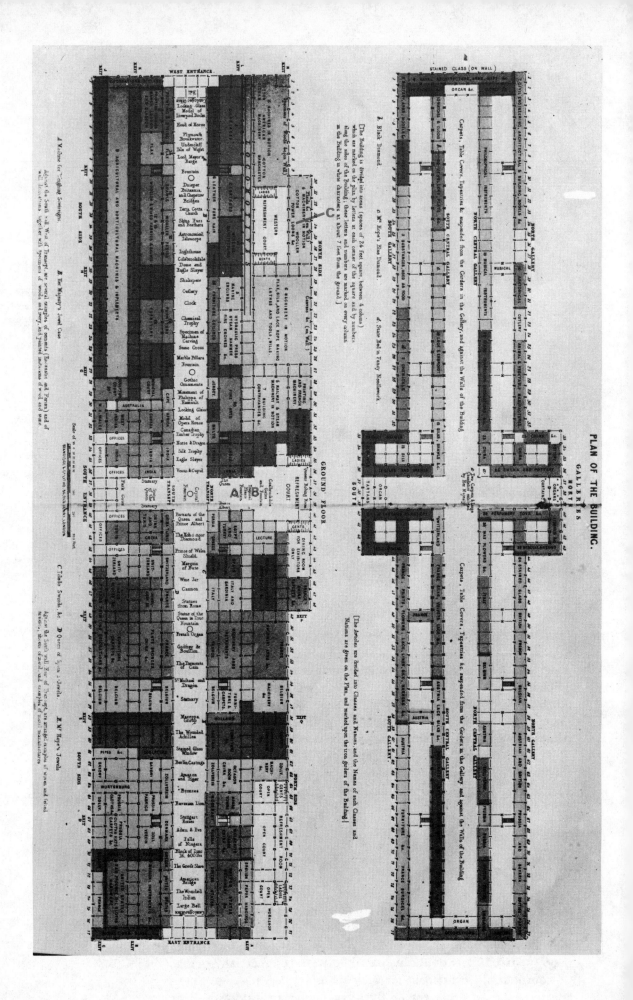

Fig. 59 Ground plan of the Crystal Palace showing the disposition of exhibition space in 1851.
For (A) see Fig. 45 and plate III; (B) plate V; (C) plate IV.

107 Thus, visitors to the Exhibition were apprised of Taylor and Sons'
improved ship's furniture: 'walnut-wood couch, forming a bed
when required, stuffed with the exhibitor's patent cork fibre, to
make it buoyant when placed in the water. Each part being made
portable is immediately convertible into a floating life preserver;
and the whole forms a floating surface of 50 feet, or life raft, in the
case of danger at sea.' (From the Official Catalogue.) Also: 'model
of a pair of trousers, so constructed that they may be worn three
different ways, either as a French bottom, or gaiters attached, or
plain bottom, with improvements.' (Official Catalogue.) Another
'improvement': 'Patent Ventilating Hats. The principle of ventilating
these hats being to admit the air through a series of channels cut in
thin cork, which is fastened to the leather lining, and a valve fixed
in the top of the crown, which may be opened and shut at pleasure
to allow the perspiration to·escape.' (Official Catalogue.) One more,
in case you have difficulty rising in time to hear the Open Uni-
versity's weekend broadcasts: The Registered Alarum Bedstead:

> By means of a common alarum-clock hung at the head of the bed,
> and adjusted in the usual way to go off at the desired hour. The
> front legs of the bedstead, immediately the alarum ceases ringing,

are made to fold underneath, and the sleeper, without any jerk or the slightest personal danger, is placed on his feet in the middle of the room, where, at the option of the possessor, a cold bath can be placed, if he is at all disposed to ensure being rendered rapidly wide awake. (From *The Expositor*)

Fig. 62 This 'Sportsman's knife' by J. Rodgers & Sons, for example, had more than 80 blades! Hardly the thing to carry about in one's pocket.

Fig. 63 Taylor & Sons, Designers and Manufacturers, Southwark. Improved Ship's Furniture.

108 There was inevitably, in an exhibition of these dimensions, a quota of eccentricities. Professor Crestadoro's 'Impulsoria', for example, was a railway locomotive housing a team of horses which moved on an endless belt to drive the wheels. A patriotic Italian, he wanted to establish railways in parts of the country which had little access to coal. A symbol perhaps as appropriate to the Exhibition itself as were 'Sibthorp's Elms' to the building, was Count Dunin's so-called 'Expanding Man'. This was an almost life-size model of a figure made up of 7,000 parts, interlinked so that they could be manipulated and the 'man' made to grow larger than life. The mechanism consisted of a series of grooved and pinned sliding metal plates, activated by a complicated arrangement of wheels, racks and tubes. Its ostensible purpose was to provide a model for tailors which could be made to duplicate the exact size and form of any person from measurements given in his absence.

109 Among the objects in the more serious, business-like side of the exhibits were, as Christopher Hobhouse notes with irony in his pithy *1851 and the Crystal Palace* (1937, 1950), 'a twelve-shilling rifle specially designed for purposes of barter with the African native, side by side with totally different models for the purpose of shooting him down. Also, from Birmingham, was a selection of shackles, leg-irons, manacles, fetters, and handcuffs for export to the Southern States of America.'

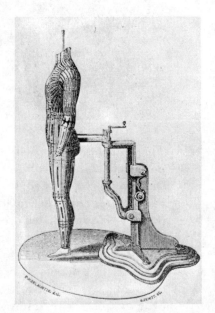

Fig. 64

110 Then, of course, there were the practical things: George Jacobs' 'Registered Protector Umbrella', the handle of which could be unscrewed, rendering the umbrella useless to anyone but the owner; a doctor's walking-stick which contained an enema and test-tubes; an irony of medical technology, a 'mechanical leech', and other handy items of that kind.

111 Reconciling spiritual with material progress, many specimens were shown of the publications of the Religious Tract Society in the Paper, Printing, and Bookbinding section. The Society's books and tracts appeared in no less than 110 languages. Their annual circulation figure was 24,000,000. By the date of the Exhibition, the RTS and its affiliated societies had distributed an estimated 549,000,000 copies of its publications in languages ranging from Manks (Manx)

to Mohawk, and including such exotic tongues as Lettish and Calmuc, Moldavian, Armenian, Urdu, Tamil and Teloogu, Nagas, Laos, Malay Low, Samoan, Malagasy, Karif and Ojibbewa. Bunyan's *The Pilgrim's Progress* was disseminated by the Religious Tract Society in 28 of the principal languages of the earth.

112 Above all, the visitor to the Exhibition was confronted by an endless array of ornamental ironwork, ornamental clocks, mantlepieces, dinnerware, and textiles of a bewildering variety – not from Britain and her colonies alone, but from every other part of the globe also. There were ornaments in leather, glass-ware, furniture, pottery, sleighs and carriages, musical instruments, jewellery, wicker-work, bee-hives and alms basins. You name it: they had it!

113 THE OFFICIAL DESCRIPTIVE AND ILLUSTRATED CATALOGUE OF THE WORKS OF INDUSTRY OF ALL NATIONS 1851 was published in three fat volumes costing 4 guineas. A small quarto volume of 320 pages (unillustrated) was available at one shilling. It ran into six editions that year. Also available was a special edition to the three volume illustrated catalogue at 20 guineas. In the three-volume work, indexes, directories, and introductory matter alone take up 299 pages. Under four main headings: Raw Materials, Machinery, Manufactures and Fine Arts, the exhibition was divided into thirty classes of subjects. Fine Arts consisted mainly of sculpture to decorate the courts of the Crystal Palace. All pictorial arts had, in the first place, to demonstrate a particular technique or use of material to qualify for entry. Of the small number of paintings on display, one employed new silica colours and glass medium; another, 'aerial tinting' which completely disguised the signs of the human hand; and a third, novel colour-printing methods in exact imitation of water-colour and oil painting, 'rendered impervious to damp'.

'aerial tinting' probably involved something like a spray-gun technique

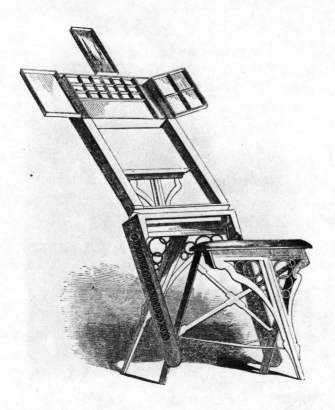

Fig. 65 'A valuable auxiliary to the amateur sketcher and the artist will be found in the EASEL, invented by, and manufactured for, Mr. F. W. Harvey, of Oxford. It is one of the most complete objects of this description we have seen, containing every requisite, on no limited scale, for both oil and water-colour painting. The easel is strong yet very light, and when closed, is perfectly secured by one stout indian-rubber band; the whole slides into a Mackintosh case, which also forms a most convenient and portable knapsack.' Utilitarian-minded critics were pleased with this design, and its restraint in ornament.

Fig. 66

An example of the variety of styles possible in
nineteenth-century European design. Here are
three silver soup tureens. All were exhibited in
the Crystal Palace in 1851. They range
from the elegant simplicity of (66), Grecian
style by Messrs. Dixon & Sons of Sheffield,
to (67), the 'melon pattern' of Hawksworth,
Eyre & Co., Sheffield, to the exceedingly
ornate (68), made by Monsieur Odiot of
Paris The Art Journal said of (66),
'. . . it is certainly not a little refreshing to the
eye, somewhat over-wearied with the constant
recurrence of the elaborate and often over-
decorative patterns of the Italian style and
those founded upon it.' And of (68), 'a
magnificent piece of sculptured silver-work',
though in ornament, wanting in the 'unity
of idea'.

Fig. 67

Fig. 68

Fig. 69

Fig. 70

The most elegant objects of design in the Great Exhibition were the carriages. A large number of them were on display. There, the utilitarian function merged happily with the forms and the surface decoration.

Fig. 69: A light park phaeton by H. and A. Holmes, Derby. The whole of the superstructure was wrought in a single piece of ironwork.

Fig. 70: The 'Pilentum' by Mulliner of Northampton. The carriage, with imitation cane-work on the body, was painted and lined blue.

114 Now all through this Unit you've been looking at *engravings* of works in the so-called 'ornamental arts'. Here, in Fig. 71, is another engraving. This one represents a wine flagon by Messrs. Lambert and Rawlings (London). It was on display in the Crystal Palace in 1851. Can you tell which material (or materials) the flagon was made from? Does it give you any clear indication of the surface texture of this object? Is the leaf motif around the neck of the flagon cut into, cast with, or superimposed upon the main form? All these things must be known if one is to assess with some accuracy the true character of the object, and evaluate it as a work of art. The fact is that the engraving tells us little or nothing about these important features of the flagon's design. It is very deficient in its information. If you want to see how deficient, turn to p. 65.

THE TRANSFORMATION OF MATERIALS

115 A characteristic feature of Victorian design was the deliberate transformation of one material to affect the appearance of another. The pages in the catalogues of the Great Exhibition are full of references to 'imitation marble', 'imitation wood'; to simulations of stained-glass, bronze, steel; to 'casts in imitation of metal'; even to imitations of ormolu, which was itself a variety of brass made to look like gold. Obviously, the imitation of fine and expensive materials had good economic reasons behind it, but we ought not to overlook the sheer delight of the Victorians in such transmutations. Not until Surrealism and its propensity for metamorphoses was so much pleasure again derived from the idea of the mutability of materials.

Fig. 71

116 To be sure, the use of materials like papier mâché to simulate wood both in structure and appearance could be justified on the basis of manufacturing expediency, cheapness and availability to the consumer; Gutta-Percha was so fluent and serviceable a substance that there was little to inhibit its counterfeiting most other materials. And in a more subtle way wood and iron and stone were each assuming the traditional functions of the others. New industrial techniques, like more powerful presses, to a large extent accounted for it. For with infinitely more ease, and at far less cost, could artwork be superimposed on essentially utilitarian objects. What had once been lovingly and painstakingly carved in wood, its limitations in design governed by that material, could now be cast or stamped in metal or other materials.

117 The extremes to which exhibitionism in the use (or abuse) of materials could go is demonstrated in a piece of sculpture shown in the Crystal Palace in that memorable year. It was called the *Circassian Slave*, executed by Raffaele Monti, an Austrian artist. You will see this, and others like it, in the television programme, 'The Nude in Victorian Art'. The veil was rendered in such a way as to give the illusion that the face of the unhappy woman beneath it could clearly be seen. What the British critic who wrote the catalogue entry thought of it is revealing. Referring to the nudity of the woman he writes: 'We confess ourselves no advocate for that style of art, which avails itself of the beauty of the female form for the purpose of exhibiting the debased consequences of the misplaced power of her natural protector. The *Veiled Slave* [*Circassian Slave*] presented no prominent compensation for doing violence to our feelings, with one exception, and that was the mechanical cleverness of creating a transparency upon the most obdurate of all mediums.'

Fig. 72 Raffaele Monti: Circassian Slave in the Market at Constantinople.

118 This disguising of the true nature of materials was considered immoral by John Ruskin and William Morris. Their purism was motivated by deep ideological convictions about the state of society and the ultimate destination of man. They succeeded in influencing, profoundly, conceptions of design even in our own century. They were perhaps the chief sources of the idea that to respect the 'integrity of the material' was an essential condition of art and design.

119 Sick at heart that his ailing idol, Turner, had exhibited no painting in the Royal Academy that year (Turner died in December 1851), Ruskin resented the public's ignorance of this fact and its preoccupation with the Great Exhibition.[1] 'The populace of England rolls by to weary itself in the great bazaar of Kensington, little thinking that a day will come when those veiled Vestals and prancing Amazons, and goodly merchandise of precious stones and gold, will all be forgotten as though they had not been . . .'

120 All this terrible cleverness, this frightening newness, continued for the rest of the century to provoke acid comments from Ruskin: '. . . whatever the material you choose to work with, your art is base if it does not bring out the distinctive qualities of that material.' Discussing 'The Work of Iron' in an essay of 1859, he sets out clearly his philosophy of materials: '. . . if you don't want the qualities of the substance you use, you ought to use some other substance: it can be only affectation, and desire to display your skill, that lead you to employ a refractory substance, and therefore your art will be base. Glass for instance, is eminently, in its nature, transparent. If you don't want transparency, let the glass alone. Do not try to make a window look like an opaque picture, but take an opaque ground to begin with. Again, marble is eminently a solid and massive substance. Unless you want mass and solidity, don't work in marble. If you wish for lightness, take wood; if for freedom, take stucco; if for ductility, take glass. Don't try to carve feathers, or trees, or nets, or foam, out of marble.' *A longer section of this essay on modern manufacture and design in which Ruskin discusses the social significance of the use of iron is in the Anthology M5.*

1 In 1906, fifty-five years after Turner's death, twenty-four of his *oil paintings*, among those bequeathed to the nation, were shown to the public for the first time at the Tate Gallery. In 1857, however, at the great Art Treasures Exhibition in Manchester (see para. 133), about one hundred Turner *water-colours* were on display.

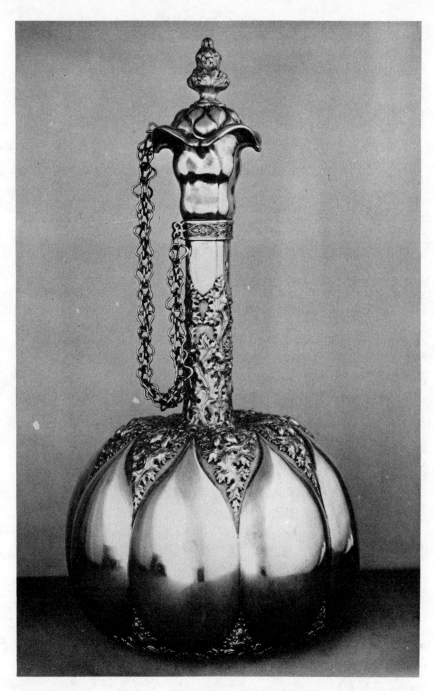

Fig. 73 Photograph of silver wine flagon made by Lambert and Rawlings, London. Shown in the Crystal Palace in 1851. Height: 22 inches. (Refer back to p. 63). Whatever charm the engravings have in themselves, look at how much more the photograph tells, though even it witholds certain things from us. Perhaps there really is no substitute for the real thing. Does this, then, invalidate all that has been said about design in the Unit? I don't think so. But this demonstration, using both photograph and engraving, is made to impress upon you the need to keep something in reserve when discussing the appearance of objects represented only as engravings.

121 Concrete plans were announced (in January 1849) to hold a Great
 Exhibition of the Industry of All Nations, almost two and a half
 years before it was to open. A few months later, in March 1849, the
 first issue of the magazine, the *Journal of Design and Manufactures*
 appeared. Among its contributors (the editorship always remained
 rather anonymous) were three men, very influential in art and
 design: Matthew Digby Wyatt, Secretary to the Executive Com-
 mittee of the Great Exhibition, William Dyce, Royal Academician,
 who served on the Design Awards Committee, and Henry Cole, a
 leading member of the Executive Committee. It seems obvious that
 the magazine was conceived with one overriding purpose in mind:
 to promote all those conditions which would help educate British
 manufacturers.

122 The *Journal of Design* was effective in causing changes to be made in
 the Copyright Acts to protect ornamental design from piracy. It
 publicised the costly and cumbersome procedures by which a
 design could be registered, serving thereby to facilitate those
 procedures. During the brief three years of its existence the magazine
 was also effective in causing the reform of the Schools of Design.
 The editors engaged some of the most distinguished writers on art
 and design to contribute to its pages. Particularly concerned with
 promoting good design in printed fabrics at a time when profits in
 textiles were threatened, they included in each issue samples of the
 actual textiles and wallpapers which they considered to be among
 the best produced in Britain (see colour plates VIII–XI). But
 just how effective they were to be on manufacturing design itself
 was hard to know before such results could be assessed in the
 Great Exhibition itself. Their constant criticisms of feebleness or
 ostentation in design products were, I believe, perceptive and
 intelligent (see Anthology L7). But could they tame those frontiers-
 men of commercialism who had plenty of drive but seemed rather
 lacking in taste? That manufacturers were already generating a
 craving for ornament and novelty for its own sake is apparent in
 their very first article, 'On the Multitude of New Patterns' (the
 whole of which is reprinted in para. 59).

123 The *Art-Union* (*Art-Journal* from 1849) with almost as much sensi-
 tivity and with equal concern, had from the mid-forties clearly
 announced similar intentions of helping to enhance the quality in
 manufacturing design by establishing some critical standards for
 the use of ornament. Yet by 1851 and the Great Exhibition, most
 critics seemed to agree that, as far as good design in manufactured
 products was concerned, the Exhibition was a flop.

124 But, of course, it was possible to have both ornament and good
 design without falsification, without the loss of organic relationships
 in form. This was apparent in a regrettably small percentage of
 Victorian design. All the later issues of the *Journal of Design*, from
 1851 to February 1852, illustrated such examples out of the
 Exhibition itself. But of the tens of thousands of items shown in the
 Crystal Palace, what, in their estimation, was worthwhile was just
 a drop in a heavily ornamented bucket. The magazine made no
 bones about it. In disgust, they used the term, 'caviare to the
 millions', to describe the manner in which manufacturers were
 advertising the benefits of the state of trade for the people. Their
 lengthy post-mortem of the Exhibition bore the title, 'Universal
 Infidelity in Principles of Design'; the opening words:

The absence of any fixed principles in ornamental design is most apparent in the Exhibition – not among ourselves only, but throughout all European nations. Many other nations shew better faith and better practice in design than those of Europe. Does the progress of civilisation and the increased value put on knowledge and labour destroy principles of taste? It might seem so. Ponder thereon.

Fig. 74 An example of beauty in utilitarian design was this Metallic Folding Bedstead by Samuel Perkes of Birkenhead. It featured in the Journal of Design in 1851. They admired its simple construction, its versatility (bed, couch, settee, crib), its lightness (16–20 lbs), portability, and the fact that it could easily be folded up and stored.

125 What was really startling in this condemnation written by William Dyce, was perhaps one of the earliest indications in the Victorian nineteenth century that the passion for ornament was antithetical to utility: 'The most serious violation of principle common to both [England and France] is the negation of utility as paramount to ornament. All European nations at the present time begin manufacture with ornament and put utility in the background. The very best things in the Exhibition are the least ornamented.' In one of their last issues a most significant article was published (January 1852) in which it was predicted, doubtless as a result of the Exhibition, that the design of the future would become more utilitarian – and more simple (see Anthology L9, L11).

For some, a feeling of satiation with ornament led to a desire to return to the sparse, ascetic, hard look of antique revival styles

126 At least one courageous attempt was made to salvage from the ornamental shambles of the Exhibition some sense of dedication to the principles of good design, and to use the Exhibition itself as an object lesson. Ralph Nicholson Wornum, the lecturer on the history of art in relation to ornament in the Government School of Design, and eminent contributor to the *Journal of Design*, wrote an essay called 'The Exhibition as a Lesson in Taste'. It won the prize offered by the proprietors of the *Art-Journal* for the best essay giving practical advice to the British manufacturer based on the lessons learnt in the Exhibition. It was published in a lavish special edition devoted solely to the Great Exhibition and illustrated with over 2,000 engravings. Wornum had no argument against ornament: He even called it 'one of the mind's necessities'. He also spoke of it as an 'essential element in commercial prosperity'. His 'Lesson in Taste' was a lengthy one, but like the others, he too, saw nothing new in the bewildering variety of ornamental design in the Exhibition; nothing that had not been done again and again in the past. The taste of the producers was uneducated he said. He tried by reasoned argument to distinguish the truly creative design, with strength and elegance of form, from the indiscriminate use of materials and pilfering of styles, the degeneration of decoration into a uniform mixture of all elements.

127 Perhaps Lewis Foreman Day's remark, 'there is no compromising with vulgarity', made later in the century, came close to the truth (see Anthology, p. 279).

128 Neither *The Times* nor *The Morning Chronicle* minced words in their denunciation of the absurdities perpetrated in that Palace of iron and glass: The greatest atrocities of taste are committed; juvenile indelicacies, ignorance in the use of beautiful materials, etc. (*The Times*). Flashy, incongruous, *tours de force*; vagaries and inconsistencies of taste; we are skilful mimics – but what do we create?;

is there no distinct style in English art? no homogeneity of feeling? (*The Morning Chronicle*).

129 It need not be explained, it seems to me, why, after February 1852, no further issues of the *Journal of Design* appeared when, ever more than before, its need should have become apparent. Even the enthusiasm of the *Art Journal* for the Exhibition ('Public taste has, of late years, increased to such an extent, that mediocre productions find little chance of sale') seems rapidly to have diminished, the emphasis put increasingly on Fine Art.

130 Other writers of the time were quite specific about abuses in design and the indiscriminate use of earlier ornament. Sacred vessels became utensils for domestic use. Greek funerary urns were turned into drinking cups; classical columns into candlesticks. Sarcophagi appeared as wine-coolers, and ceiling decorations on carpets. Carved friezes were printed on muslin curtains.

131 The *coup de grâce* to the Great Exhibition was dealt by Richard Redgrave in his 'Report on Design'. Redgrave, a highly respected teacher and Royal Academician, was esteemed for his sensitive writing on art and design. He, too, had earlier contributed to the *Journal of Design*. Though he appreciated the benefits which could come from the machine, he believed that ornamental art was best fulfilled by handicraft, and that it had most grievously suffered from its new union with machinery.

> Wherever ornament is wholly effected by machinery, it is certainly the most degraded in style and execution. . . . This partly arises from the facilities which machinery gives to the manufacturer, enabling him to produce the florid and overloaded as cheaply as the simple forms, and thus to satisfy the larger market for the multitude, who desire quantity rather than quality, and value a thing the more, the more it is ornamented.

The effect of the stamp, the mould, the press and the die, he says, is a sickening and monotonous sameness unknown either in the works of handicraft or in nature (*The Illustrated Magazine of Art*, vol 1, 1853).

POSTSCRIPT

132 An ironic conclusion to the story of the Great Exhibition, and a significant one, was the occurrence, in 1857, of the 'Art Treasures Exhibition'. That, very likely, was the largest and most heavily attended art exhibition ever held – before or after, anywhere in the world. What is more – and this is the irony of it – it was held in the citadel of British manufacture: Manchester. Now what would Manchester want with an exhibition of the Fine Arts, not of the manufacturing arts, the kind we've been looking at, but mostly of paintings and sculpture and objects out of the richest artistic tradi-

tions of the past? Why should the merchants and manufacturers of that city have agreed to support an undertaking of that kind? Why, indeed! The good citizens of Manchester were told in no uncertain terms by one of the noble Dukes (Devonshire?): 'What in the world do you want with Art in Manchester? Why can't you stick to your cotton-spinning?' (*The Burlington Magazine*, Nov. 1957).

133 I said that the Art Treasures Exhibition of 1857 was probably the largest of its kind ever. The statistics are staggering. At least 16,000 works of art were shown from all periods and all places. These included over 1,100 paintings by old masters and almost 700 by contemporaries. Sculpture and portrait paintings numbered over 500. Photographs were put on view. The rest of the objects exhibited included the finest works of the ornamental art of the past known to mankind: furniture, armour, small-scale sculpture in terra-cotta and bronze, oriental ceramics, Italian majolica, glass, porcelain, enamel, objects from Europe's foremost collections and from its great museums. The number of famous old masters shown is truly remarkable: 28 by Rembrandt, 39 by Rubens, 16 by Poussin, 17 by Claude, 24 by Velasquez, 25 by Van Dyck (whose pictures in the portrait section numbered 38). The seventeenth-century Dutch masters were well represented. So were the sixteenth-century Italians, Raphael especially, the Venetians, and eighteenth-century French. Early English artists were represented mostly by Hogarth and Reynolds. About 100 water-colours by Turner were shown. The complete list is, of course, far more extensive than this and included a small number of contemporary British artists, Pre-Raphaelites and others. An extensive section, devoted to prints, included, as an example, 79 etchings by Rembrandt. To repeat; 1,100 of these! How long do you think it would take you to have even a cursory look at all of them, not to mention the other 15,000 works of ornamental art? I give you all these figures to impress upon you the magnitude of the event. All the more strange, then, to hold it in industrial Manchester.

134 During the five months the Art Treasures were on view, over 1,300,000 admissions were recorded, an astronomical figure, especially if you take into consideration the population of the country then. Imagine the equivalent today, with the population, say, doubled. *That* would be a headache for some of our public galleries!

135 What surprised many contemporaries, and pleased them too, was the sudden revelation of an unsuspected wealth of art in British collections. Many of the objects seen in Manchester were borrowed from Royal collections and from the treasures of the British nobility, a product of the patronage of generations of those families in the arts. Not a few works came from the collections of the new bourgeoisie. Many of the Art Treasures of 1857 now belong to the Nation.

136 To return to the questions: Why an Art Treasures Exhibition? And why in Manchester? What reasons would you give in answering them? Don't bother to write your answers here. Just take time out to think of what you've already read in this *Industrialisation and Culture* block and how fitting (I called it 'ironic'), in more ways than one, it was to hold the exhibition in that City.

137 First of all, the impetus for the Art Treasures Exhibition seems to have come directly from the Great Exhibition. The Great Exhibition (as you have seen in reading the foregoing summing up) failed to

establish the excellence of British design – in the eyes of the British at least. *It was this failure that helped to reinforce the belief that there could be no worthwhile ornamental art without a great understanding and appreciation of Fine Art.* Prince Albert, a leading patron of the Exhibition in Manchester, and others of similar mind, very likely saw the expediency of inculcating the British public, and the world outside, using the Art Treasures of Britain to raise the Nation's 'temperature' for Fine Art. Remember, no proper Fine Art Exhibition was held in 1851. And now, six years later, it was time to make amends.

138 Manchester was chosen, ostensibly, because of its central location in the Kingdom, and its superb railway facilities. One suspects, however, that that City (not always forthcoming in its patronage of the Arts) was selected for more subtle reasons having to do with raising the 'taste quotient' where it was most needed: the industrial Midlands. But Manchester wasn't all poverty and filth. There was, among its government and leading citizens a certain enlightened element. Asa Briggs speaks of it in his book, *Victorian Cities*. He points to the 'cosmopolitanism' of the place, the international character of its trade, and the many foreign merchants and workers who settled there. These also were contributing factors to its cultural aspirations.

139 John Ruskin was invited to Manchester in 1857 to deliver two lectures relating to the Exhibition. One wonders why Ruskin, without doubt the greatest authority on European art of the period, had nothing to do with the organisation of that exhibition. Perhaps the reasons can be found in these lectures. For, unexpectedly, instead of delivering learned addresses on Masters in European art, he used the occasion to drive home to the merchants and manufacturers of Manchester, the need to establish a set of social principles concerning the execution, the accumulation, and the distribution of works of art. He put a certain value on the quantity of art treasures accumulated in the country, though not solely on the pride in preserving great art. He spoke of them as the 'real wealth' of the Nation. But, most of all, he valued them only in so far as they could be made to produce the richest results. And the richest results, to him, meant to bring art within the reach of the multitude. He called for more and larger galleries and for a means by which that art could be made available in the homes of people: '. . . to accumulate so much art as to be able to give the whole nation a supply of it, according to its needs, and yet to regulate its distribution so that there shall be no glut of it, nor contempt.' But, best of all, Ruskin would have liked to see those art treasures returned to their homes in the countries of the world. How much prouder it would be, he said, to send people to travel in Italy, or to whichever other place those art treasures were returned, and there to say, 'Ah! this was *kept* here for us by the good people of Manchester'. How much better for England, he believed; how much better for Europe.

*Fig. 75 The Queen. Reproduced (c.1848)
by Bate's Patent Anaglyptographic Process
from a bust by Sir Francis Chantrey, RA
(1781–1841).*

LOOKING FORWARD

140 Can a machine, by itself, with no human intervention at the production stage, make a work of art? Must a work of art be *made* at all? Must it in some way be touched by human hands? Can a rock, or a waterfall, be a work of art by itself – even if we do not know of its existence? Or do we make it a work of art by calling it a work of art? If a piece of agate, or driftwood which pleases us could be called a work of art, why shouldn't some linear configuration, like this one, made entirely by a machine set in motion by the human hand, unique, and visually engaging, be considered as a work of art? These are questions often posed today. In the *Introduction to Art* Tim Benton suggested that the crucial factor is what the *spectator* thinks about the work of art. We have quite a different attitude to the machine now than critics had in the nineteenth century. Because so many artistic works by hand look like they were produced by machine, and are considered attractive, we are not so inclined to see some malevolent mind behind the machine, and we are quite prepared to call designs produced by machines, art. Such considerations probably anticipate some of your own as you read this section on the mechanisation of art. It is well to keep in mind how insoluble they are, and how difficult it is to dismiss out of hand the kind of art which bears the stamp of the machine.

Fig. 76

THE ARTIST IN THE COMPUTER

141 Will computers soon take the place of artists? It's a question you might well ask. For today computers can be made to draw and paint, write poetry and compose music. You may not find these works appealing, not all of them anyway, but the capacities of computers as artists are only just being realised. Push-button design for ships and cars is just around the corner. Already, computers can turn out perspective drawings of any object almost on demand. They can 'instruct' cutting and carving machines to make – automatically – models and parts for objects as diverse as dungarees and battleships according to what information these 'thinking' machines (more accurately, calculating machines) are fed.

142 At the Massachusetts Institute of Technology (M.I.T.) a system called 'Sketchpad' has been perfected which allows engineers and designers to alter the dimensions or the composition of a drawing (made with an 'electronic pencil' and viewed on a television screen), to see it from any desired angle, and to decompose or recompose it almost at will.

143 And more recently, using IBM computer facilities in California, Mr. John Whitney has filmed, in sequential series, computer-generated designs that keep changing shape. These arresting forms can be produced in the viewing units of digital-computer graphic systems in infinite varieties. They can now, at the push of a button be reproduced on paper at the rate of 15 to 38 seconds each, depending on the complexity of the image.

144 But these are only electronic equivalents to forms produced purely mechanically a long time ago (Fig. 80). They are not new. Nor is

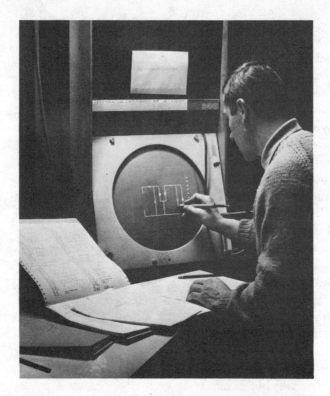

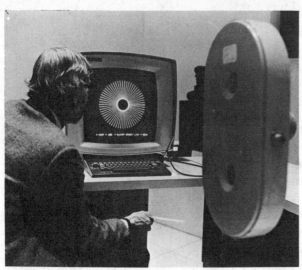

Fig. 77 Left: Using a 'light pen' on cathode ray screen.

Fig. 78 Right: Isometric and orthogonal projections of a wire-frame chair. From M.I.T. 'Sketchpad' project.

Fig. 79 John Whitney records computer-generated patterns on film.

the appreciation of them new. The main difference is that while such images were earlier thought of only as curiosities or amusements, they are now seriously considered as art.

145 'Well, yes', you might say, 'Computer art is all right but it's bound to look mechanical. What about the 'aesthetic' side of design?' Not surprisingly, it has already been suggested that even *that* may be controlled by using information derived from outstanding works of art, from Greek pots to Picasso paintings. The computer may take and isolate the aesthetic measure of things: the essences of symmetry, a-symmetry, rhythm, contrast, harmony, unity, concentration, etc. The guts, in short, of art.

146 Well, what happens when the quintessential characteristics of art are applied in a mechanical way? Let's take this charming example of a love-letter, composed by a computer. It was used by Jeremy Sandford in the *Observer* in April 1963:

Fig. 80 *Designs made by a pen attached to a pendulum, and a swinging tablet. Apparatus by Joseph Goold, Nottingham, 1890s. Similar devices can be purchased in toyshops today.*

Honey dear, my sympathetic affection beautifully attracts your affectionate enthusiasm. You are my loving adoration; my breathless adoration. My fellow feeling breathlessly hopes for your dear eagerness. My lovesick adoration cherishes your avid ardour.

<div style="text-align:center">

(signed) Yours wistfully,

M.U.C.

(Manchester University Computer).

</div>

This may successfully win the heart of another computer, but it is unlikely to quicken the pulse of any real and eligible lady or gentleman.

147 Computers can make music too, either by composing the actual sounds or by printing out the 'composition' for the instrumentalists to play. The Bell Telephone Laboratories (USA) issued an album in the early 1960s called 'Music by Mathematics' containing examples of different computer compositions.

148 What is missing in computer art and poetry? What is the magic ingredient which would make it more like art as we know it?

149 My guess is that it is mainly *irrationality* that is missing. For surely a large part of human communication is through a kind of symbolic *misuse* of the rules or, to say it in another way, we agree on how we will make mistakes. In general, the artistic process, it seems to me, creates its own organic and ever changing realities. And it communicates, not with the mind alone, nor only with the eyes or different sensory organs, but with the whole being. No machine as yet can successfully fulfil these functions.

150 But wait! The dauntless and high-spirited programming masters, the supermen of automation, aware of this shortcoming in the machine, now propose to *allow it to be non-rational – random*. They are exploring the constituents of chaos and disorder, randomness and uncertainty, in the service of the machine, to allow it to produce conceptual responses. But will this effect the triumph of machine-made art over man-made art? *Will it make the personal, the human, element in art ever more precious?* Or is it just an innocent activity, no different really from what happened in history?

THINKING ABOUT MACHINES

151 For many centuries artists have taken the machine – so to speak – into their confidence, as a servant to art, as a means for making their art more believable, and in the industrialised cultures of the nineteenth century especially, commercially, to save time and effort, and morally, to make it more available.

152 The history of the use of optical and mechanical devices by artists is a long one. As it became important to artists to produce exacting reproductions of nature, they sought the authority which was often bestowed upon an impersonal mechanism, in hopes of establishing fixed and immutable laws which would regulate the representation of the external world. Utilising the machine, many artists hoped to arrive at a set of absolute conditions which would govern all creative activity. But most of them found in the machine simply a means of easing their labours, or they let it discover for them unusual forms

which they explored in a way consistent with their preconceived aesthetic notions.

153 Just as some philosophers, writers and their followers reacted *against* the growth of science and technology, and their reflection in contemporary thinking, some artists too felt it a matter of principle to reject the concepts of the rationalists. They preferred to retain as much as possible in their works the signs of the hand and the soul; individuality, mystery and imagination. These views of art have always been with us.

154 But in the great technological onslaught of the Industrial Revolution, machine thinking seemed to encroach more and more on the general mentality of the age – as certainly it did in design. In 'Signs of the Times', written in 1829 by Thomas Carlyle, we shall find a reaction to this state of affairs, romantic perhaps, but not without a strong dose of truth. Men, he asserted, had lost their belief in the invisible and put their faith only in the visible, preferring to the spiritual and the divine, the practical and material world:

> Men are grown mechanical in head and in heart, as well as in hand. They have lost faith in individual endeavour, and in natural force, of any kind. Not for internal perfection, but for external combinations and arrangements, for institutions, constitutions – for Mechanism of one sort or other, do they hope and struggle. Their whole efforts, attachments, opinions, turn on mechanism, and are of a mechanical character.

(You will find a longer extract in the Anthology A1.)

155 Despite Carlyle's assertions, many responsible and sensitive people applauded each new advance in science and technology with the deep conviction that ultimately, if not immediately, the machine would be made to benefit, not to degrade, mankind; to assist, not to replace, art. Motivated by such attitudes, artists and designers at the end of the nineteenth century, and in the first few decades of this, made no bones about where they stood in relation to industrial technology and the machine. The concept had evolved that there was a kind of beauty inherent in the machines themselves. The *engineers*, it was asserted, stood at the forefront of the new art. In 1901, the architect, Frank Lloyd Wright, produced a manifesto on the art and craft of the machine. In 1910, a group of Italian artists who called themselves Futurists, rather pugnaciously insisted that the new art must be concerned with contemporary life, transformed by the miracles of science and technology. They dedicated themselves to the concept of a 'Universal Dynamism', symbolised by the speeding motor car, by the aeroplane, by electricity and the cinema. They exalted urbanism: the advertising poster, the factory system, trains, machines for peace and machines for war, and all the noise, confusion – and anxiety – of modern life.

156 In 1913, the banner was passed to a group of utilitarian-minded artists in Russia:

> We declare the genius of our days to be trousers, jackets, shoes, tramways, buses, aeroplanes, railways, magnificent ships! What an enchantment! What a great epoch unrivalled in world history!

Art was dead, they believed, an escapist activity. It was not *style*

they wanted, but 'the product of an industrial order like a car, an aeroplane . . .'

157 The story of art, science and technology in the twentieth century will have to be told elsewhere. But it is an interesting story; an important one in the understanding of modern art.

Invention of arts, with engines and handicraft instruments for their improvement, requires a chronology as far back as the eldest son of Adam, and has to this day afforded some new discovery in every age. (Journal of Design and Manufactures 1850. From Defoe's 'An Essay upon Projects' 1697.)

OPTICAL AND MECHANICAL AIDS TO ART

158 The use of external devices in making works of art dates in the west, at least from the fifteenth century. Perspective machines, particularly, interested artists. A great variety of these were employed from the fifteenth-century Renaissance well into the nineteenth century. Of all the equipment used by artists in those five hundred years, none was so universally appreciated as the camera obscura, the instrument which later became the photographic camera.

159 Not only artists, but interested amateurs were encouraged, especially in the eighteenth century, to avail themselves of 'machines' like the camera obscura as, for example, a 'means for taking a landscape or copying a picture without knowing how to draw'.

Fig. 81

Fig. 83

Fig. 82

160 As in the modern photographic camera, the natural image entered the camera obscura either through a tiny hole or a proper lens, inverting itself. But until the invention of light-sensitive emulsions, the 'picture' in the box was simply projected on to paper, canvas, or some other material, placed at the proper focal plane. The artist, either in a darkened tent or under a cloth hood, got his head and hand inside the box to trace the outlines or sketch in the tonal masses of the image he saw there.

161 Obviously, there were reservations about this practice, just as later with photography, objections were raised about its use by artists. The 'soul' would go out of art. Art would become a mere process. Naturally, it had to do with the artist concerned. There were always those whose dependence on the machine betrayed a lack of understanding or ability. And there were others whose *use* of the machine was deliberate, intelligent, and an indication of a lively and creative mind.

162 In the nineteenth century, as you would expect, there was an unprecedented interest in such contrivances. Modifications of perspective machines, pantographic tracing tools of one kind and another, and several variations of the camera obscura appeared in the 1820s and 1830s. What better way to convey to you their variety than by naming them? A measure of the excitement and enthusiasm with which they were generated is given in the language used to describe them.

Fig. 84 A camera lucida in use (nineteenth century).

Fig. 85 The Agatograph (1834).

Fig. 86 Gavard's Diagraph (1830–31).

163 There were the Pronopiograph, the Quarreograph, and the Universal Parallel. There were also the Eugraph, the Diagraph, Agatograph, Anaglyptograph, Ediograph, and a Pantograph described as 'monkey correct' (in French, 'singe perfectionné'). Another pantographic machine by an inventor called Charles

Schmalcalder was described as a delineator, copier and proportiono-
meter, one part of which moved over the features while another
drew or cut out a silhouette. The camera lucida, Solar Megascope
and the Graphic Telescope were new devices employing prisms or
lenses.

164 The press announced each invention with enthusiasm: 'a new
instrument for perspective'; 'another wonderful discovery'; 'marvels
in art'.

165 Most of the implements named were employed solely to obtain
greater precision in the representation, and as labour-saving devices.
But there were many others used specially to make multiple copies
of earlier or contemporary works of art.

THE MULTIPLICATION OF WORKS OF ART

166 A substantial number of chemical and mechanical methods for
manufacturing facsimile copies of art are referred to in the official
catalogue of the Great Exhibition. Among them are Frederick
Rowney's 'typo-chromatic' colour-printing method for the multipli-
cation of drawings and paintings. Water-colours and oil paintings
both were reproduceable by this and other colour-printing tech-
niques described in that catalogue. The reproduction of mono-
chromatic originals (drawings, engravings, etchings, lithographs,
mezzotints) was, obviously, an easier matter, and several such
processes are described. These included so-called 'Anastatic'
printing methods, like the 'Appelotype' which, with other *photo-
graphic* methods, are prototypes of our own photocopying techniques.
These were also useful in the reproduction of music, maps and
printed texts.

167 Engraving methods (like one called 'Tornography'), either for
duplicating or for converting three-dimensional forms into their
pictorial equivalents, were extremely clever, as was a still newer
means for turning sculpture into wood-carving by machinery.
'Transfer Zincography', is the name of yet one more method for
copying medallions and sculpture. And if the normal capacity of
engraved plates, either in copper or even in steel, was not sufficient,
a method was developed whereby three thousand prints could be
taken by transferring the image to lithographic stone; a procedure
which, in essence, meant that an infinite number was possible.
That was the situation in 1851. The number of 'improvements'
advertised in the first half of the century was even greater.

168 Making multiple copies of works of art in painting or sculpture was
not new in the nineteenth century. Nor was it a product solely of
industrial culture. The Aztecs of Mexico, for example, reproduced
most of their small figures (humans and animals) in clay moulds.
And, of course, the multiplication of drawings by means of print-
making techniques has been known in the west for about 500 years,
and in China, much earlier. But in the late eighteenth and nine-
teenth centuries those techniques became much more sophisticated
and could be used to duplicate many more kinds of things. Methods
even for the reproduction of oil paintings, with all their brilliance of
colour and with perfect fidelity, were known in the late eighteenth

and early nineteenth century well before the discovery of photography was announced to the world in 1839. Not unexpectedly, with the coming of photography, all processes used earlier for the reproduction of two-dimensional images were, sooner or later, critically affected – or eventually made obsolete.

169 Typical of the moral rectitude which moved hand in hand with this 'democratisation' of art was the belief that the labours of genius could now be placed within the reach of Everyman. The mind and the spirit will be elevated. Every man will be surrounded with such things as will 'breathe an air of goodness over his soul'.

170 As in the reproduction of the more or less utilitarian objects already discussed in Unit 33, the question again arises whether this was detrimental to or to the good of society. The capacity of the machine to bring more art to more people is on the one hand both desirable, and on the other, corrupting, as the appreciation of these things may diminish in relation to the ease with which they are acquired. That was the case made out by Ruskin. Furthermore, the way was open for flooding the market with trivia, and then creating a system to guarantee its consumption. That could be seen rather as the scourge of commerce than its beneficence.

REPRODUCTION IN THREE DIMENSIONS:
JAMES WATT'S CARVING MACHINES

171 Among the many inventions of James Watt (1736–1819) were machines for the facsimile reproduction of letters and other documents, written or drawn, anticipating present-day office copying machines, and for the multiplication of sculpture. Concerning these latter machines, Sir David Brewster later (1848) described the 'excellent' copies of bas-reliefs and small complete statues he'd seen in Watt's house at Heathfield, near Birmingham. Watt kept his invention secret, mostly because of imperfections in the patent laws and the trouble he was already having in the law courts over improvements in his steam engine.

172 Watt's 'Garret Workshop' (as it is called) was a kind of microcosm of industrial engineering. Though small, it contained an extraordinary number of mathematical instruments, hand and machine tools, milling tools, woodworking tools, minerals, chemicals, moulds and modelling materials. Several unfinished devices for drawing in perspective, on which he'd worked earlier, a cardboard box with a lens (probably a camera obscura), something like a calculating machine, and a number of other similar objects were there, among an estimated more than 6,000, to keep the inventor occupied during his retirement from the famous firm of Watt & Boulton until his death in 1819.

173 Watt became interested in sculpture machines about 1804, though such devices for the reproduction of medals and reliefs were known much earlier. Watt's sculpture machines were operative, and examples of their work were found in his attic room. One of the machines functioned as a lathe, and turned out copies reduced in size on the principle of the pantograph.

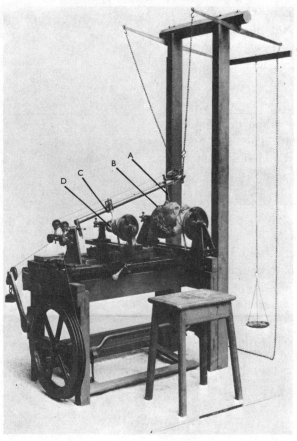

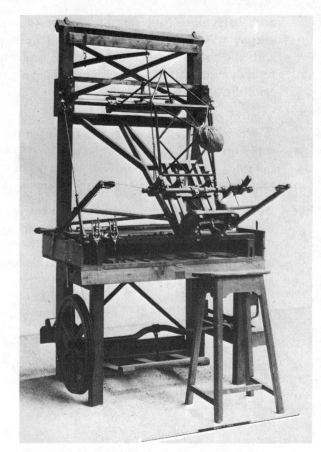

Fig. 87 Fig. 88

174 A probe (A), following all the contours of the original (B), trans-
 mitted its movements to a cutting tool (C) which acted accordingly
 upon the material to be carved (D).

175 About 1807, Watt began work on a larger machine, one which
 could produce facsimile-sized copies and in the round. This worked
 more or less on the basis of present-day so-called spindle-carvers.
 Again, a probe moved upon the contours of the master, communi-
 cating each articulation of surface to drills which could carve two
 copies at once.

176 Compared with later machinery of that kind, the production of
 sculpture was a bit on the laborious side. In 1811, it took Watt a
 total of 39 hours to execute and fit together a pedestal and bust.
 Those sculptures, mostly experimental, were carved in hardened
 plaster, alabaster, and sometimes in wood – though the machine
 was being improved to take materials as hard as marble. Towards
 the end of Watt's life it looked as though his machine would move
 from the experimental to the production stage. Watt sat for the
 sculptor Sir Francis Chantrey in 1815, probably telling him then of
 his carving machines. Chantrey, whose work was very much in
 demand, became interested in having some of it reproduced.
 Excited about the possibilities of Watt's machines, he corresponded
 with the inventor in 1818. But it was too late. Watt died in the follow-
 ing year, and with the development of other machines based on
 similar principles, Chantrey pursued his interests elsewhere.
 Chantrey, whose later bust of Queen Victoria was copied by means
 of the Anaglyptograph (see frontispiece to this Unit, p. 72), had
 often used the prismatic device known as a camera lucida (Fig. 84)
 to ascertain the exact contours and precise relations of the facial

planes in his preparatory drawings. He also figured in a parliamentary inquiry (in 1846) concerning machines for copying medallions and other objects in relief.

CHEVERTON'S CARVING MACHINE

177 Among other notable three-dimensional reproduction processes, was a machine perfected by an inventor named Cheverton. Cheverton's carving machine had also been kept secret for many years during which time he produced for the commercial market perfect ivory miniatures from full-sized models. Probably, Cheverton's method too was based on the pantograph principle. The operation, almost entirely performed by machine, and accurate even to the reproduction of surface blemishes, was hailed in the *Journal of Design* as analogous to the two most important photographic processes, the daguerreotype and the calotype. The possibility of reducing with precision monumental works of art meant that sculptures of large size could now be brought down to drawing-room proportions. Surprisingly, even the scrupulous and tasteful *Journal of Design* had no qualifications to make about such a practice. They even went so far as to recommend that a colossal alabaster figure from the Parthenon pediment (in the British Museum), be first rendered by the Cheverton process and then combined with the electrotype to give it a metallic surface (see para. 43).

178 This kind of thing was often done. Indeed, it is still done today. What do you think happens to the artist's original conception of a work in sculpture, executed in large dimensions, and rendered in a particular material, when it is reproduced considerably smaller and in another material? How is the work changed?

179 I'd agree with you if you said that a sculptor is very strongly influenced both by the size and the material of his work. Sometimes the influence is obvious, governing the purely physical character of the object. More indirectly, perhaps intuitively, a consciousness of size and material will, to a significant extent, determine the very proportions, shapes, poses and gestures, and surface handling of the object. If the size and/or the material is significantly altered, all

these elements of form may lose both their meanings and their power. Furthermore, the object may only 'work', or work better, in its original context – with architecture on a plinth, up high to be seen from below, in a dimly lit interior or in bright sunlight. Still, considering the other possible benefits of putting art 'literally' in the hands of many people, may make the more purist attitude about form a bit precious. Whichever view one takes, it is well to know the differences between an original in its natural form and setting, and a reduced copy in an alien environment.

'JORDAN'S PATENT'

180 Not only might the heightened demand for works of figurative sculpture be satisfied by the use of carving machines, but also the taste for ornament in architectural detail – especially where it concerned mediaeval revival styles. Stamping leather by machine was a convenient way of simulating old ornamental wood carvings; burning wood in iron moulds was another – the charred parts giving it the appearance of age. But these two methods were limited because of the difficulties of undercutting and obtaining sharp edges.

181 Carving machines were for those ends superior. Another machine, then called, 'Jordan's Patent', was a rather simple, yet extremely effective spindle carver – in principle, not unlike those of Watt, and somewhat related to present-day key-cutting machines which undoubtedly you know. Jordan, whose workshop was in the Strand, described his machine to the Society of Arts in 1847. Fixed to a 'floating' table was the work or pattern to be copied. On a vertical plane were the tracing and cutting tools. The original object was moved under the trace which responded to each contour, transmitting those movements to two spindles which acted simultaneously upon blocks of wood placed beneath them on the table, and running on the same rails as the original (study Fig. 89).

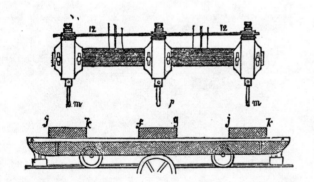

Fig. 89

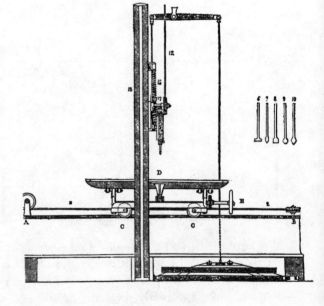

182 The power came from a treadle worked by foot, rotating the drills at from 5,000 to 7,000 rpm. That, roughly, was how the carving machine worked. Undercutting, of course, was possible simply by

84

turning all pieces in their clamps as and when required.

183 Mr. Jordan's own words, describing the advantages of his machine, are revealing:

> I believe that machinery will do for the sculptor and carver what engraving has done for the painter, and I believe that it will do it without throwing out of employ any class of artists or artisans, however talented, or however humble; for machinery cannot do the work of the mind, although it can assist very materially in copying it.

He speaks of the difficulty and expense of finishing by machine – but this is good luck for the workmen:

> By this system every class of workmen now employed as carvers will continue to be so; and a great increase must necessarily take place in their numbers, by reason of the increased demand always attendant on cheap production. But one of its best features, so far as the progress of Art is concerned, is, that it still leaves the artist full power over the material he employs, and enables him to give to the world repetitions of his best works, with his own ideas and his own touches embodied on their surface. For we can take his clay model, or rather the cast from it, and by careful manipulation on the machine, in a few hours, send him three or four copies of his work; and then a few hours more of his talented labour will make each of our machine productions equal to the original design.

184 It might be worth saying here that many artists, before the nineteenth century, ran studios much as picture factories. Rubens, for example, often would put the finishing touches to large canvases, executed to his designs, by a staff of assistants.

PARIAN

185 I have already discussed (paras. 43 and 44) the facility with which stamped or pressed objects, coupled with the electrotype process, could be made to simulate, at a fraction of its original cost, a unique and expensive work of art.

186 Another process for doing the same thing, by moulding, made use of a clay body called Parian. Parian was introduced by the potters Minton and Copeland in the 1840s. By 1850, with some modifications, Parian (also designated Statuary Porcelain) was widely used. Parian, simply, was a malleable substitute for marble, perfectly suited to the manufacture of highly ornamented objects and lending itself particularly well to the reproduction of sculpture.

BATE'S PATENT ANAGLYPTOGRAPH

187 Several purely mechanical methods for turning a piece of sculpture into a line-engraving were known in the 1840s, though most of these applied only to objects such as low reliefs and medallions. But about 1848 an inventor named John Bate perfected a reproduction process on which he'd worked for about ten years. By this process, extremely accurate linear representations of free-standing sculpture could be made. The mechanism was called, Bate's Patent Anaglyptograph.

188 The engraving illustrated here, called *The Friends*, was made with the Anaglyptograph from the sculptured group by William Behnes and published in the *Art-Union*. A vertical trace, following every contour of the subject, transmitted the corresponding movements to an etching point which worked on a steel or copper plate. Whenever the trace was lifted over a projection on the surface of the model, curved lines were scratched on the plate; the greater the relief, the more curved the line. The details illustrated here will show you more clearly the mechanical regularity of the result.

Fig. 90

Fig. 91

Fig. 92

In this particular case, it is very likely that the manufactured and impersonal, rather than the hand-made look, was the desirable thing. Why?

189 Because it was a copy (even in two-dimensional form) of a piece of sculpture. Unlike a painting, where the nuances of brush-stroke, and even of colour, would have to be translated into some linear system (as you'll soon see), a work of sculpture, much more an *object*, is absolutely measurable in its contours and proportions. Conceivably, one could make a copy of a work in sculpture (in three-dimensions) indistinguishable from the original. Not so in painting. Even a perfect photograph of the same size in natural colour would fall short of reproducing its subtle stratifications of surface. Even a cast taken of a painting would fail in the co-ordination of its colours with the variations of its relief.

190 But in such engraved copies of sculpture, something very like the original was possible – and desirable. In fact, if you move back from Bate's illustrations, the lines will blend in much the same way as the dotted screen of a newspaper photo-reproduction. In effect, the copy of *The Friends* is a photograph. You may ask, 'Why, then, wasn't a photograph used, instead of an engraving?' The answer: the primitive techniques of photo-mechanical reproduction at that date were too uncertain, too costly, and to paste in actual photographs (as was done in more expensive publications) wasn't economically feasible.

191 We've been looking at copies of sculpture, made for the printed page. Here are two blown-up details of engravings made in 1848. Both are copies of paintings.

Fig. 93 Cupid Disarmed. *Engraved by P. Lightfoot from a painting by W. Hilton, RA.*

Fig. 94 *Portrait of Napoleon. Engraved by J. Roberts from a painting by C. L. Eastlake, RA (1815).*

192 Take your time and look very closely to see, in detail, the way the subjects are rendered. If necessary, use a magnifying glass. Notice first the *variety* of hatching techniques used to obtain, in linear form,

a tonal modelling. In the *Cupid Disarmed*, how many different engraving patterns can you count?

193 I would list the following: (1) the variations on the lozenge and line used in the flesh, becoming (2) dotted contour lines in the lightest areas, (3) the mosaic-work rectangles of the sky, (4) the woven tapestry form in the foliage, (5) the simulation of each strand of hair, and (6) contour ribbing in the scarf – I count six distinct techniques. The methods used in the Napoleon portrait are different again, with a system of dotting in the flesh tones, an open-weave background, and a simulation of twill in the cloth of the hat.

194 Now, if you stand back and do not look too closely at, say, Napoleon's cheeks, you will notice something like a pattern of interlocking curves formed by the dots. This is a clue to the way in which all these intricate etching patterns were made. How long do you think it would take to scratch out each little lozenge, each interwoven segment, each cluster of dots, by hand? (Remember, you are looking at enlarged details, only one-eighth to one-sixteenth of the whole of the engravings.) Too long, I think, to make it economically worth while. In fact, the hand, in a sense, was only a guide to the machine. Special tools were used, and very expertly. Many of them, with the desired patterns cut into 'rockers', 'stipplers', and 'roulette wheels', could be used to plough the surface of the plate with ease (see 'Engraving' in your copy of Murray, *A Dictionary of Art and Artists*).

195 So, with the unreasoning veracity imparted by mechanical tools, the engraver, *as a copyist*, must subordinate his feelings to the *process*.

196 Now, compare those two engravings with this one (reproduced in actual size) made a bit earlier, in 1842, by the French artist, J. J. J. Grandville for a book called *Scenes from the Private and Public Life of Animals*.

Fig. 95

What do you see as the main differences?

197 You've probably noticed that compared to the mechanical appear-
 ance of the first two, the Grandville looks more 'natural', more
 'personal', and fluent. By contrast, the former, however florid,
 seem contrived, schematised, cold and calculated, hard and rigid.
 They describe all matter, hair, flesh, fabric, with some kind of linear
 formula. You might also have commented on the anonymity and
 apparent lack of sensitivity transmitted by the first two prints, and
 the warmer, more sensuous quality of the third. Perhaps you feel,
 as I do, that an even more subtle thing comes across in the Grand-
 ville. That is, the commitment of the artist in his intimate response
 to the subject.

198 Now, this difference is to be expected where, on the one hand, the
 artist is bound to make himself into some kind of machine, and on
 the other, a commentator. Not that all copyist engravers were unable
 to contribute anything of their own. Many of them were distinguished
 for their abilities to interpret – to translate – into black and white
 linear form, all the subtleties of a painting rendered solely in colour
 tones. And often their copies were admirable in themselves. Some of
 Turner's engravers had such reputations, and well deserved too
 when one thinks of the broad masses of colour which characterise
 Turner's paintings. But rarely could engravers take more liberties
 than that. All things considered, the practice of remaking painting
 and sculpture created by others, carried with it a certain mechanistic
 inevitability.

199 Nor was this simply the product of a highly sophisticated industrial
 society. True, in the nineteenth century, to meet the needs of a
 proliferating popular illustrated Press and a growing consciousness
 for art, pictorial reproduction techniques grew at an unheard-of
 rate, unprecedented in the finesse of its techniques. But would you
 say that the following two engravings are any the less mechanical-
 looking than the Cupid and Napoleon referred to above?

200 Probably not. Yet they date from the sixteenth and seventeenth
 centuries. The one on the left is a detail from an engraving of
 Bacchus by Hendrik Goltzius (1558–1616), and that on the right by
 Étienne Baudet (c.1636–1678). Both are enlarged.

90

Fig. 96

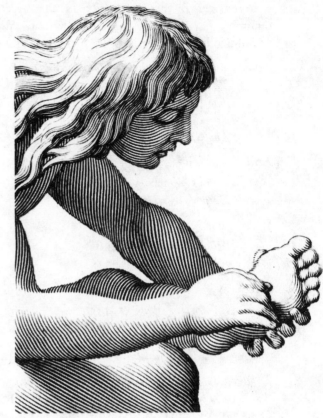

Fig. 97

PICTURES FOR THE MILLIONS

Every application, whether it be physical or mechanical, which aims at rendering good art economical, deserves our most serious attention.

(The *Art-Union* 1848)

201 In 1839, the discovery of photography was made known to the world. It was not then apparent to most people that in so far as inexpensive monochromatic reproductions of works of art was concerned, photography would eventually eclipse all other methods. That year, adding to the growing list of 'new discoveries in art', two methods were proposed for the multiplication of works of art. The first, by means of lithography, was Dupont's system for reproducing early engravings. It was stated that that system would cut the cost of an engraving to one-fifth its usual selling price. 'It threatens the graphic arts – engraving and printing – with a complete revolution'. (The *Art-Union* July 1839.) The second, reported in the same issue, was an invention by Jacobi Leipman of Berlin, for the mechanical multiplication of oil paintings with all their brilliancy of colour retained.

202 Many other techniques for the facsimile reproduction of painting and the graphic arts were reported that year, as in all other years at the time. It seems, sometimes, to have in that period reached the proportions of a mania. Most of those inventions were little heard of later as obsolescence now became an intrinsic factor in each new discovery. Their significance may be more in the urgency with which pictorial reproduction techniques were pursued than in their operational effectiveness. We should note that this period, which

was marked by great activity in the invention of reprographic techniques, is also the period which saw the birth of a modern, popular, illustrated Press:

> *The Illustrated London News* (1842).
> *The Pictorial Times* (London 1843) later absorbed into
> *The Lady's Newspaper*.
> *The Illustrated Times* (London 1855–59) costing 3d. in 1855.
> *The Graphic* (London 1869).

And in America,

> *Leslie's Weekly* (1855) and
> *Harper's Weekly* (1857).

In France,

> *l'Illustration* (1843) and
> *Le Monde Illustré* (1857).

Germany,

> *Illustrirte Zeitung* (1843).

Holland,

> *Hollandsche Illustratie* (1862) only ran that year.

At least twenty illustrated magazines appeared in Europe at the time. In New York alone, six were issued. Mexico, Brazil, Uruguay, Canada, Australia and South Africa had theirs.

Additionally, there were the satirical journals like

> *La Caricature* (1830),
> *Le Charivari* (1832), and
> *Punch* (1841).

Popular science magazines,

> *The Scientific American* (1845),

and yet others.

Periodicals illustrated with wood-engravings were, of course, known earlier. Preceding the *Illustrated London News* in Britain they included *The Penny Magazine*, and newspapers like the *Observer*, *Bell's Life in London* and the *Weekly Chronicle*. But these were not heavily illustrated, nor were many such publications available then. The *Illustrated London News*, and magazines like it, began a new era in visual communication.

THE ILLUSTRATED LONDON NEWS

203 In the context of Victorian design and manufacture and the moralising about art for everybody, the developments of reprographic techniques and a popular illustrated Press was bound to elicit discussion about its significance as art. Views tended to polarise. On the one hand it was believed that the wood-engravings in magazines like the *Illustrated London News* were wholesome and beneficial; on the other, that 'art' in the form of cheap and easily available prints was corrupting and harmful. These two views are exemplified in the *Journal of Design* (1850), and in 1857, by John Ruskin in his Manchester lectures at the time of the Art Treasures Exhibition (see para. 139). This is what was said in the *Journal of Design*:

It is becoming part of the habit of the people at large to *want* some art, and they get it. 60,000 people want every week the art of the *Illustrated London News*, and would feel a blank in their lives if they were deprived of it; and it is curious to remark how progressively the art in that periodical has improved since its commencement. The art in that paper is decidedly *useful* art, mixed up with the events and sympathies of the day; and to this cause – a very natural and wholesome one – we may attribute its surpassing success, whilst other illustrated, and even cheaper periodicals, which treated subjects more foreign and unnecessary to every-day life, have become extinct. The *Illustrated London News* is itself a great fact full of hope for the progress of **Design**.

204 Ruskin, no less concerned with the edification of the people, was fearful that the cheapness of art in reproduction would not only create an ephemeral art, a throw-away art, but an emphemeral sensitivity for art. Here, his argument was sometimes one-sided. One good 'woodcut' for a shilling he said (and I am sure we wouldn't argue with him) is worth twelve bad ones at a penny apiece, an obvious reference to periodicals like the *Illustrated London News*. Ruskin doesn't pose the corollary: twelve good woodcuts for a penny apiece, are worth more than one bad print at a shilling. But he had another objection. Quantity. Having too many things, even good things, was in itself corrupting. Having too many bad things, like the prints in cheap illustrated magazines, was worse, for it killed the sensitivity for the better ones. Prudence and restraint, then, was one of the useful economies society could practise in art (lecture in Manchester, 1857). He opposed the idea, put forth by many generous-minded people, that good art ought to be made cheap and placed within the reach of everybody. Art should never be made cheap, beyond a certain point, he said, 'for the amount of pleasure that you can receive from any great work, depends wholly on the quantity of attention and energy of mind you can bring to bear upon it'. Ruskin meant that our powers of appreciation are diminished if we were to spread our enjoyment of art over many pictures – 'fragments of broken admirations' he called it.

205 Which one of the following statements best describes Ruskin's attitudes about art?
1 Having one bad woodcut is better than having twelve bad ones.
2 No good art can be reproduced cheaply.
3 It is better to have one good work of art than two.
4 Even good art is not good, if one has too much of it.
5 A work of art which is reproduced cannot be good.
6 Any art which is reproduced cheaply cannot be good art.
ANSWER ON PAGE 102.

206 With thirty engravings advertised by the *Illustrated London News* for 6d. in 1842, the opening editorial on the first page of the first number harped on the importance to society of this new publication: 'Art – as now fostered in the department of wood engraving – has become the bride of literature, and there is now no staying the advance of this art into all the departments of our social system.'

207 Now what was the character and quality of those engravings in the *Illustrated London News* which were admired so much by the *Journal of Design* and repudiated by Ruskin?

208 First, Ruskin's reference to 'woodcuts' pertains to the method used in making the blocks for printing, in the *Illustrated London News* or in most other illustrated magazines of the time. The technique involved the engraving of small pieces of hard and close-grained wood. These blocks, were cut from the box tree in transverse slices, and as that tree was normally 7 to 10 ins. in diameter when put to use, the dimension of the blocks, when trimmed, were most often considerably smaller, frequently measuring 3×4 or 3×6 ins., and seldom larger than 4×6 ins. Now, considering the fact that the pictures in the *Illustrated London News*, and other magazines mentioned in para. 202, were often 8 to 10 ins. wide and up to 12 ins. high, and sometimes, when spanning two pages, 12×20 ins., can you guess how such larger engravings were made and what implications that process had for the character of the image? Look carefully at Fig. 98 and comment in the block below.

209 In the production of larger engravings, the practice was to drill several blocks and bolt them together to make one of the required size. On this, the drawing was executed, often from a rough sketch made by the artist in the field. The blocks were then separated and engraved with the various cutting implements so that the raised portions could receive the ink and make the printed impression. What do you think the main problem was, when cutting a picture from multiple blocks?

It was that of eliminating or disguising any signs of 'joins' between the blocks. This problem was largely overcome either by cutting the contiguous areas of the blocks to begin with, or by leaving the periphery of each block ungraved, and when the separate parts were bolted together again one engraver would make all the transitional cuts. At first glance one is seldom aware that these engravings are composite. But now that you know, look closely at this reproduction (Fig. 98), not from the *Illustrated London News*, but from another pictorial weekly, *The Graphic*, of 1888, and see for yourself. The subject is a news item: the rescue of Belgian aeronauts in the North Sea by a British ship. It is reproduced slightly smaller than actual size.

Fig. 98

1. The Balloon with an Anchor Trailing in the Sea 2. The Rescue 3. The Balloon Disappearing into the Clouds 4. M. Coulet, the Aëronaut

RESCUE OF BELGIAN MILITARY AËRONAUTS IN THE NORTH SEA BY THE BRITISH STEAMSHIP "WARRIOR"

95

How many separate blocks can you count?

I see the faint divisions of blocks vertically, running along the ship's funnel, then just left of the balloon's lower ring, and again left of the vignettes at the right. There are four vertical segments in the engraving, and two horizontal, making a total of eight blocks. If you look at these junctures through a magnifying glass you will see how carefully the linear transitions were made. Engravers were quick to use all kinds of devices for disguising these seams where the separate blocks were joined. One such device is used here. Can you tell what it is?

The picture was made to conform to the multiple-block engraving by placing the horizon line at the horizontal junction point. The seam therefore becomes a meaningful line in the drawing and is read as the division between sea and sky. Often architecture, with its straight lines, offered the illustrator ample opportunity to hide the composite character of the engraving. And so the composition was not solely determined by actuality, or by aesthetic preferences, but by the exigencies of the reproduction technique.

211 Well, that is a problem which need not cause any great changes in the style of execution. *But* a single artist did not always cut all the blocks making up one image. Those illustrated weeklies like the *Illustrated London News* were picture factories. A full page illustration, for example, measuring, say, 9 × 12 ins., would have taken one man about two or three weeks to engrave. For economy, and for the sake of speed, engravers often specialised so that one did the figures, another the landscapes, someone else the architecture. The division of labour wasn't new in art, having been practised earlier in the west and to some extent in Japan in the manufacture of prints. In making these prints for the illustrated periodicals, often, after the drawing was made, the blocks were separated and distributed amongst two or more engravers. Sometimes, under pressure of time, the blocks were distributed as soon as parts of the drawing were completed. Occasionally, draftsmen never saw the whole of their drawing intact. Now this really posed a problem. What do you think it was?

212 The problem was one of uniformity in the engraving; how to prevent a hybridisation of style. Despite the fact that one artist made the drawing, often interpreted from the drawing of the artist in the field, inevitably, several hands at work engraving that drawing would tend to produce certain disparities in style which might not cohere visually when the finished blocks were clamped up again for printing.

213 In scrutinising the pages of the *Illustrated London News*, one would therefore expect to discover in the largest prints especially, a number of such discrepancies. But even a practised eye will seldom be able to discern that. Why? All engravers, working collectively, had to aim for a stylistic similarity. Even when single engravers worked on small blocks, it was expedient that his style of cutting be not too dissimilar to the overall style of the periodical. Not that there was that much need to control style either. The demands made by pressure of time, and especially by the fact that those blocks would have to stand up to an enormous number of impressions (see circulation figures for the *Illustrated London News*, para. 94), would be great determining factors in the way in which those engravings were made, though methods for casting metal printing plates from the wood were known and widely used from about the mid-1840s. Engravers, in fact, were specially trained to subordinate all signs of personal statement to the demands for an impersonal and uniform system.

214 One therefore finds in the pages of the *Illustrated London News* and other magazines of the kind, none of the diversity of styles to be seen in the prints of contemporary artists. In fact, one of the *differences* in style in magazine illustration occurs as the result of yet another mechanical process brought into wood-engraving. That is, the photographing, rather than the drawing of the image to be engraved, on the block. I will come back to that later.

215 So, I am saying that there are fewer significant differences in style in such engravings, than there are in the styles of artists whose prints are not meant for the pages of newspapers or periodicals. Do we now assume that the uniformity applied solely to the production stage?

216 No. We must assume that the artist who made the original drawing on the composite block, or for that matter on a single block, did so with these problems of production in mind. In other words, he catered to the needs (so to speak) of the machine, just as designers of ornamental works of art did, mindful of the methods used to manufacture those objects. This is certainly so in cases where the artists sped up production by drawing directly on the block in front of the scene to be reproduced, as, for example, was done by an *Illustrated London News* artist, John Gilbert, in the early 1840s.

217 It should interest you to know that in Britain few of those engravings are signed as, for example, they were in France. The names of the artists and engravers working for the *Illustrated London News* are almost as anonymous as those of mediaeval manuscript illuminators. Often, we know their names from other sources than the pictures themselves.

THE COLOSSEUM PRINT

218 In the first year of publication (1842) the *Illustrated London News*

announced that all those subscribing weekly to the journal for the first six months would receive free a gigantic print, a panoramic view of London from the top of the Duke of York's Column. This was known as the 'Colosseum Print', and it was at the time eagerly sought. Including its margins, the print measured $3 \times 4\frac{1}{3}$ ft., and though it wasn't the biggest wood-block ever made it does rank with the gargantuan examples of the species. The engraving was made up of no fewer than 60 pieces of wood.

219 It may have struck you that to draw the view of London from 124 ft. up inside the constricting interior of that monument, must have posed special problems for the artists concerned. But no. The view was recorded by the photographic camera, cumbersome, but much quicker. Antoine Claudet, one of the best-known daguerreotypists working in London at the time, took a sequential series of plates which were then translated by drawing on to the block and then cut by no less than nineteen engravers over a period of two months. The problem of keeping the whole image homogeneous in style must have been difficult for Ebenezer Landell whose firm was engaged to execute the print. Yet here too, no less than in the smaller composite blocks, there is even less sign of deviation from a uniformity of style.

220 | Can you say why?

Because there would have been a near absolute uniformity of image in the daguerreotypes. In copying them on to the blocks, the artist, and in turn the engravers, would have been highly influenced by the flat tonal patches with which a photograph renders volume. Furthermore, photographic tone lends itself well to the simplification of wood-block cutting. That, plus the obvious desire to get a pictorial consistency in the engraving itself, would almost guarantee a high degree of regularity in the appearance of the picture.

221 I want now to demonstrate to you the way in which photographs (at that time particularly) rendered volumes, and how they tended to appear when converted into engravings. When you compare this photograph of the famous Victorian photographer of the Crimean War, Roger Fenton, sitting on his photographic van (a mobile darkroom) in 1855, with an engraving made from it for the *Illustrated London News*, what strikes you about the photograph itself and the engraving made from it?

Fig. 99

Fig. 100

Comments

222 What first strikes me is that almost the whole engraving could have been made by using a ruler – right down to Fenton's clothes. It 'neatens up' the photograph – makes the image crisper. What next strikes me is this: the engraving style is noticeably different from that of other engravings reproduced here from the same magazine If you look at Fenton's face in particular in this enlarged detail (Fig. 101), you will see that the features are rendered in a very schematic way by patches of dark and light – much as the photograph renders them (Fig. 102). Keep in mind that from about 1851, photographs were often made right on the blocks themselves, and engraved directly. There is no attempt, as there is in this engraving (Fig. 103) made from an original drawing (also from the *Illustrated London News*), despite its mechanical appearance, to convey the 'architectural' structure of the features by a linear modelling which follows, or at least acknowledges, the solidity of objects – as you can also see in this detail from Grandville's engraving (Fig. 104) given in the original size here. Look at Fenton's right eye: just a shadow *suggesting* the structure of his brow, socket and lid. His beard merges with the shadow of his neck – as in the photograph. As in the photograph too, the bridge of his nose is shown, not in linear form, but as a light area differentiated from the cheeks only by the clues given in the bits of linear contour above and below. Certainly, more extreme examples can be given.

Fig. 101

Fig. 102

Fig. 103

Fig. 104

223 You may wonder why I have gone into such detail here. I've done it because the rendering of form by patches of light and shade, in that particular way, came straight from the photographic camera. To say it more precisely, the kinds of non-panchromatic emulsions then in use, distinguished between colour-tones very poorly. That resulted in large, often unintelligible areas of dark or light. Photographs of that kind, the tones exaggerated by reproductions made from them, either in engravings or, from about the 1880s, in half-tone screen reproductions for books, newspapers and magazines, were influential on illustrators and even on painters to the extent that it could be called a characteristic element of modern styles. We ourselves are accustomed to an imagery derived largely from photographs, and may not question its validity as others did earlier. Critics of 'modernism', referring to that kind of tonality, did not hesitate to hang on it epithets like 'mechanical', 'meretricious' and even 'degenerate'. Yet that kind of tone helped form the styles of artists as well-known as Edouard Manet, Toulouse-Lautrec, and many others equally distinguished – and was a product of modern techniques.

Fig. 105 *Detail from a photograph by Alexander Gardner (1865).*

Fig. 106 *Detail from a pastel portrait of Méry Laurent by Edouard Manet (1882). Some of the subtle colour tones will be lost in this black and white reproduction.*

224 More than ten years before photography was 'officially' invented, at least one photo-mechanical printing process had been possible. In 1826, a Frenchman named Joseph-Nicéphore Niepce succeeded in etching photographs of early engravings using the same plate on which the photograph was made. In essence, the method was simple. A light-sensitive substance called bitumen of judea formed the emulsion on a pewter plate. The engravings to be copied were made transparent by oiling or waxing and used as 'negatives', in contact with the sensitised plate. All areas exposed to light became hardened. The unexposed parts were dissolved leaving in their place the bare metal which was then etched in the usual way, and printed.

225 That same method, though with other emulsions like albumen plus the light-sensitising bichromate of potassium, or bichromated gelatine, was the basis for many subsequent photo-mechanical reproduction processes. From 1839 there was no let-up in the effort to perfect the means by which any photograph could be accurately reproduced by printing, cheaply, and in unlimited quantities. Obviously, the proliferation of illustrated newspapers and magazines, both creating and satisfying a public demand for them, was the driving force behind the many photo-reproduction methods which marked the last half of the nineteenth century, and which has not diminished to this very day.

226 It would be superfluous to retail their names here. But of them all, the most efficient, though not the finest, was that species of techniques known broadly as the 'half-tone screen' photo-reproduction process. Today, we are most familiar with the 'cross-line' variety of the half-tone processes made practicable about 1885. The method was used in England as early as 1852 by William Henry Fox Talbot (one of the discoverers of photography). But it was employed commercially, perhaps for the first time in a newspaper, in March 1880, in the New York *Daily Graphic*. In the 1880s, following further developments in the technique, half-tone screen reproductions ultimately became universal in use. It might make you pause to think when I tell you that the half-tone illustration in the *Daily Graphic* was the view of a shanty town in New York. I leave it to you to consider the implications of the massive bombardment on human consciousness which the 'actuality' of the photographic image in reproduction has had.

227 As far as art and technology are concerned, here we may be enlightened. We have seen how the demands for mass production in pictorial illustration, based on new techniques in wood-engraving, and on photography used with wood-engraving, resulted in what has been called a degraded imagery. Now, with a further mechanisation of pictorial reproduction – half-tone photo-reproduction – something very important happens. Of what significance to art was this later process?

Comment briefly here:

228 I would say that it eliminated the interpretative stages in the printing of works of art. Now, a photographic technique, by producing original works of art in facsimile form, *raised* the standard of pictorial illustrations.

229 Here is a case where the shortcomings of one graphic technique were mitigated – or even eliminated – by a further and more sophisticated one. If, like Ruskin, you have reservations about the ultimate advantages of the large-scale propagation of art, you might consider the concomitant importance of the need to exercise restraint in personal choice.

230 Which statement best describes Ruskin's attitudes about art? (p. 93). Statement number 4, I think. Keep in mind that Ruskin was not against the reproduction of works of art. He did want art to be within the reach of many people, though not so easily that they would become jaded by it.

Fig. 107 John Ruskin (1819–1900).

Fig. 108 William Morris (1834–1896).

231 I would like to discuss with you the style of writing of Ruskin and Morris. This, I think, is worth doing **before you read the extracts provided in the Anthology.** Ruskin and Morris are not easy for us to take. Often, at first, their writings repel. Why? Because they wrote, I believe, in a style which is peculiar and unfamiliar to most of us. It was, to say it simply, a preaching style; highly repetitive and hortatory. The theme of damnation and salvation underlies much of their written work, and though the evangelical ring tends to grate on contemporary ears, it was not out of place in the nineteenth century. That 'sermonising' may well count as an important factor in their popularity, even among those who objected to their ideas or would resist their demands.

232 Why, then, should it be necessary to plough through their often long-winded expostulations? Mainly, I think, to get the undiluted flavour of some of the most pungent critical writing on art of the time. Because Ruskin and Morris have proved to be so prophetic, they become particularly important in the study of modern industrial civilisation. To put in its proper perspective the earlier discussion of design, and the mechanisation of techniques in art and design, a good strong dose of Ruskin and Morris is needed. Without it, our conception of the dilemma posed by the industrialisation of society might be too cold-blooded, too tabulated, like that computer love-letter you read in the previous section.

233 Now it is important to understand that most of the extracts in the Anthology are reproduced from the texts of *lectures*. They were written with the lecture in mind. Even the essays meant by Ruskin and Morris for the printed page alone are characterised by a lecture style.

234 Whether or not there was any intention of presenting the material in public, the 'straight-talk', the direct appeal to the listener, is there. Ruskin:

> 'My dear reader . . .'
>
> 'I will tell you presently . . .'
>
> 'I see that some of my hearers look surprised at the expression . . .'
> (*The Political Economy of Art*)
>
> 'Would you not say . . .'
>
> 'I assure you . . .'
>
> 'And now, reader, look round this English room of yours . . .'
> (*The Nature of Gothic*)
>
> 'If you will tell me what you ultimately intend Bradford to be . . .'
> (*The Two Paths*)
>
> 'I say you have despised art! "What!" You again answer, "Have we not art exhibitions, miles long? And do we not pay thousands of pounds for single pictures?" '
> (*Sesame and Lilies*)

235 Almost all of Morris's published writings on art (though not his prose stories or poems) were in the first instance, composed and delivered as lectures. Under the titles, *Hopes and Fears for Art*, and *Architecture, Industry and Wealth*, at least thirteen lectures are printed. These were given in Manchester, Birmingham, Nottingham, Leicester, Oxford and London, between 1878 and 1892. Others, or parts of others, are preserved in newspaper accounts. Regularly, each year, Morris delivered a few lectures on art. What he had to

say could not be conveyed by his craftsman's tools alone. Lewis Foreman Day, who often attended these talks by Morris, recalls that there were no changes made in the printed versions. When you read them, he says, 'you seem to hear him speak'.

'My friends, I want you to look into the relation of Art to Commerce . . .'

'If I could only persuade you of this . . .'

'So, you see, there was much going on to make life endurable in those times.'

'Are you surprised at my question . . .?'

'You whose hands make those things that should be works of art . . .'

'But I think there will be others of you in whom vague discontent is stirring . . .'

236 According to Day, Morris's delivery was downright simple and frank, devoid of the 'deliberate artificiality' of his prose stories:

So obviously convinced [was he] of the unanswerable truth of what he said, that he carried conviction with him . . . even when he was most mistaken. . . . He had a way of talking and writing as if he were opposing someone, and must bear his adversary down. The fact is, probably, that he felt himself so much in opposition to the normal habit of philistine thought, that he looked for resistance, and made haste to get in the first blow.

237 Who were the audiences of Ruskin and Morris? Who read their books and pamphlets? Mostly, it seems, the educated and cultivated middle classes. But also, and not infrequently, their audiences, curiously, were the very people they scolded in their talks. You will remember that at the time of the Art Treasures Exhibition in July 1857 (see para. 139), Ruskin gave two long lectures in Manchester to an audience composed largely of merchants and manufacturers. A Daniel in the lion's den. His subject, much to their surprise, was not Italian Quatrocento painting, or art itself for that matter, but the political economy of art. The great and revered writer on art had come to talk politics! Ruskin took it upon himself to instruct those present on the proper and most socially responsible use of wealth, and how it pertained to Art.

238 When Ruskin published the four further essays on political economy which make up *Unto this Last* in the new *Cornhill Magazine* in 1860–61, he said they were 'reprobated' by most readers in a violent manner. In those essays Ruskin, more than ever before, trespassed in areas forbidden to art. He put art and the labour of art in its broadest social, political and economic context. He stepped 'out of line', and berated English society, calling for the things he believed really to enrich human life. This was not very happily received and he was in one instance reminded that some 'Philanthropic gentlemen are infinitely too ready with their pity' (*The Saturday Review*).

239 Similarly, another series of essays on political economy, appearing in 1862–63 in *Fraser's Magazine*, were discontinued, after the first four were printed. Ruskin later collected them under a title which came from Horace: *Munera Pulveris*. Translated as 'Gifts of Dust',

it apparently describes the theme: the insubstantiality of material wealth.

240 In 1865 his *Sesame and Lilies*, a small collection of lectures, appeared (see Anthology, p. 293). There, as in other writings of the '60s, Ruskin berates his public for their vulgarity in respect of the arts and of nature, and also for their lack of compassion for men.

241 In his lectures and writings of the 1870s Ruskin increasingly dealt with the theme of political economy. His intense interest in art, and his refusal to see it as an isolated social phenomenon, led him, inevitably it seems, to politics. For such impertinences he invited the scorn of many of his contemporaries.

242 Yet despite the hostile reception to his work in those years, Ruskin in 1870 was offered and accepted the distinguished position of first Slade Professor at Oxford – the Chair of Fine Art. Oxford suited him well, as later it was to suit Morris. His lectures attracted large and sympathetic audiences at a time when a growing portion of the public no longer took his words as holy writ. Now, nothing, either in art or in life, escaped the critical scrutiny of the great reformer. It was then (1871) he began to write his little magazine, *Fors Clavigera*, a series of open letters dedicated to the working man, and a receptacle for all his passionate and erratic outbursts on subjects ranging from the abolition of machinery and cities, to the proper and dignified use of language.

243 *Fors Clavigera* (John Ferguson suggests that it means something like Chance, the club or key bearer, an esoteric but fitting double reference, probably, to the club of Hercules and the key of Janus) has appropriately been called 'a long and passionate soliloquy' (Peter Quennell, *John Ruskin* 1949). The title, like those of other works of Ruskin written at the time for the ordinary man: *Munera Pulveris; Aratra Pentelici* (Ploughs of Pentilicus, the mountain near Athens from which the marble for the Parthenon came), is strangely cryptic, and suggests, as do the letters in *Fors*, an introverted turn of mind and a preoccupation with personal fantasies. But in the more lucid passages of the text, Ruskin's Utopian 'republic', like Morris's later in *News from Nowhere*, is described in extraordinary detail – as though he had been there, and it worked.

244 Both Ruskin and Morris passionately believed that art must no longer be the prerogative of the privileged. Their support, however, came mostly from the privileged. They themselves were financially independent, with no fears for their livelihood. They often held forth before small working class audiences who came more, probably, to hear about Socialism than about art. Lecturing on Socialism in Manchester in the early 1880s, Morris was disconcerted that there, 'the workmen seem on the whole to identify themselves with the middle classes'; not so, he felt, with his Edinburgh audiences.

245 Morris's membership in the Democratic Federation in 1883 made him, it seems, impatient and inconsiderate of those who came to hear him speak. His lecture on 'Art, Wealth, and Riches' in March that year to the Manchester Royal Institution was heavily tinged with Socialism, and it earned him the hearty rebuke of his audience. 'On the theory of art [writes J. W. Mackail, Morris's biographer, in 1899] people were willing to hear him gladly, much as they would hear a preacher from the pulpit on the theory of religion. . . . But

when he attacked the structure and basis of the life they led . . . there were murmurs of alarm and resentment.'

246 And with little wonder. Here is Morris in that lecture speaking of the present state of art: 'So far from everything that is made by man being beautiful, almost all ordinary wares that are made by civilised man are shabbily and pretentiously ugly; made so by perverse intent rather than by accident . . .' And on architecture: 'It is a matter of course that almost every new house shall be quite disgracefully and degradingly ugly. . . . Why cannot we have . . . simple and beautiful dwellings fit for cultivated, well-mannered men and women, and not for ignorant, purse-proud digesting machines?' One can well imagine the furore in the meeting hall when Morris flung this at his well-to-do audience:

> I tell you it is not wealth which our civilisation has created, but riches, with its necessary companion poverty; for riches cannot exist without poverty, or in other words slavery. All rich men must have someone to do their dirty work, from the collecting of their unjust rents to the sifting of their ash heaps. . . . If competitive commerce creates wealth, then should England surely be the wealthiest country in the world, as I suppose some people think it is, and as it is certainly the richest; but what shabbiness is this rich country driven into?

247 In his reply to an indignant letter in the *Manchester Examiner*, Morris stubbornly insisted that the question of 'popular' art was a social, not an aesthetic one.

248 Morris, like Ruskin, usually found his Oxford audiences sympathetic – though not always. He lectured there in 1883, once with Ruskin in the chair, and on another occasion when he was invited to speak before a Liberal undergraduate club in University College. That time he chose the subject, 'Democracy and Art'. The address was well received in the crowded hall until at the end Morris suddenly and quite candidly announced that he spoke as an agent for a socialist organisation, encouraging those present to join it. This thoroughly disconcerted the Master and group of dons on the platform who'd expected the lecture to be on art in a democracy, and certainly not a vehicle for red propaganda. This unfettered ingenuousness of Morris, sometimes sprung on his audiences just to disconcert them, is clearly conveyed in the printed texts of his lectures and even in his prose writing.

249 It becomes clear that all those who came to hear Ruskin and Morris lecture were by no means already converted to their way of thinking, nor did they go away converted. Were those audiences so naïve or unsuspecting that they failed to anticipate the harangue to come? Or was it a strange homage they paid to men whose brilliance, whose love of art, whose sincerity, they admired, but with whom they may not have agreed? That may to some extent account for the unusual degree of deference bestowed on Ruskin during the Whistler Trial in 1878 (N.B. radio programme with this Unit). Ruskin at the time received much support from the court, the press, and one presumes from the general public too.

250 There is, of course, the matter of *style*. Ruskin and Morris both had commanding ways of presenting their arguments. Though Ruskin could, and often did deliver the direct and unadorned statement,

his style, compared to that of Morris, was much more circumlocutious, more subtle in the way he would weave apparently diverse elements into one convoluted pattern of thought.

251 I don't doubt that among their followers were those whose devotion sprang, to say it crudely perhaps, from the entertainment value, despite reservations about the content of the lectures. We must not underestimate the importance of entertainment in those lectures, nor the fact that Ruskin and Morris had become celebrities – successful in part *because* of their 'scandalous' behaviour. Before television and the cinema, lecture-going was the *divertissement* of many people. It was for them a kind of theatre, and the names of distinguished nineteenth-century artists and writers, who regularly stumped the country on lecture tours make a long list which included figures like Carlyle, Dickens, Whistler and Wilde.

252 If Ruskin lacked humour, he at least had wit. On one occasion he was berated for disparaging the use of iron in manufacturing. How, his irate correspondent asked, are your books printed and their paper made? Ruskin's acid response was:

> Sir, – I am indeed aware that printing and paper-making machines are made of iron. I am aware also, which you perhaps are not, that ploughshares and knives and forks are. And I am aware, which you certainly are not, that I am writing with an iron pen. And you will find in *Fors Clavigera*, and in all my other writings, which you may have done me the honour to read, that my statement is that things which have to do the work of iron should be made of iron, and things which have to do the work of wood should be made of wood; but that (for instance) hearts should not be made of iron, nor heads of wood – and this last statement you may wisely consider, when next it enters into yours to ask questions. (Quoted in Quentin Bell, *Ruskin*, 1963. From *Fors Clavigera*.)

253 Morris showed little inclination towards that kind of sharp and brittle rejoinder – and even less for humour. Somewhat indifferent to the taunts of his critics, he rather bluntly thrust forward on each issue with, as Mackail says, 'the aloofness of some great natural force'.

254 Artists and craftsmen with whom Ruskin and Morris were associated were expected to follow a rigorous routine in their creative activities, and (as far as Ruskin was concerned) in their private lives as well. Ruskin would insist, as on occasion he did with the Pre-Raphaelite painter, Dante Gabriel Rossetti: Change your 'careless way of using colour'; 'what horse's legs!'; 'are *they* in armour too or only rheumatic?'; why were there 'black spots in the highlights?'. Ruskin called Rossetti a 'conceited monkey' when the artist complained, and he audaciously insisted: 'Keep your room clean and go to bed early. . . . If you do right I shall like it – if wrong, I shall not.'

255 To some extent such impertinences were mitigated by the unstinting support, including financial assistance, given by Ruskin to artists in his favour.

256 Lewis Day, writing in 1899, the year of Morris's death, comments on the way in which Morris, who had an immense capacity for work, inspired work at his famous design establishment at Merton

Abbey: 'Morris expected work of his work people. Work was no hardship to him, and he did to his workmen always as he would have been done by'. Similarly, in his writings he practised, by and large, what he preached.

257 I would now like you to turn to the Anthology, and bearing in mind what we've discussed in this *Industrialisation and Culture* block so far, read the whole of Sections M and N (Ruskin and Morris) including those extracts you were asked to read earlier. **Then go on to the Assignment.**

Here are the two statements about art and the machine which I mentioned to you at the beginning of these Units on art and industry. One is an extract from an article called, 'The Fine Arts in Florence' by Sir Francis Palgrave (1788–1861), Fellow of the Royal Society, antiquarian and populariser of Mediaeval English history. The other is from an article, 'Machine-made Art' by Lewis Foreman Day, some of whose writings you are already acquainted with. Palgrave's article first appeared in 1840, in the influential magazine, *Quarterly Review*. Day's was published 45 years later in the *Art Journal*. Their views are almost diametrically opposite, yet we cannot say with certainty that one is right and the other wrong. This may sound like the making of a dilemma, and maybe it is. One thing is certain, however, and it is that the dilemma (if we can call it that) is not a nineteenth-century one. I believe it is with us today, though in the essay I want you to write, you may want to disagree with that. The questions posed in these writings by Palgrave and Day, bring into focus many things which have been discussed in the whole of this *Industrialisation and Culture* block (Units 29–36), and you should feel free to go beyond the *Art and Industry* Units in fortifying your views. We would like to know that our attempt to present several facets of the character and complex conditions of British society in its most intense period of industrial growth has enabled you to see them as organic parts of a culture. So, your assignment is this: first read Palgrave and Day, then write an essay of 1,000–1,500 words on the theme, *Art and the Machine*.

Sir Francis Palgrave: 'The Fine Arts in Florence' from *Quarterly Review* (1840):

> It is our *civilization* that has degraded the artisan by making the man not a machine, but something even inferior, the part of one: – and above all, by the division of labour. He who passes his life in making pins' heads will never have a head worth anything more.
>
> Of course there is no branch of the plastic or graphic arts which can be followed, unless the professor is, to a certain degree, a workman. But the connexion between *aesthetics* – we use this somewhat pedantic term out of pure necessity – and *the craft* was, so long as the habits or opinions of mankind did not run counter to it, of singular efficacy in the training of the man, giving to the artist a discipline which is now wholly irretrievable. Taste was called into constant action, without being talked about, or thought of. In the daily manipulations of the *artefice*, his genius was constantly called out upon matters of practical application and need. All the higher modes of intellect, all that cleverness and sensibility of hand, quite as essential as inventive genius, were called into action, elicited, taught, by the calling in which he gained his daily bread. These are advantages which we have lost, and for ever, by the vast improvements which modern days have effected in machinery.
>
> The means of multiplying elegant forms by punches, squeezes, moulds, types, dies, casts, and like contrivances, enable us to produce objects with a sufficient degree of beauty to satisfy the general fancy for art or ornament, but so as to kill all life and freedom. A permanent glut of pseudo-art is created; the multitudes are over-fed with a superabundance of trashy food, and their

appetite will never desire any better nutriment. Without pursuing the remark into the finer branches of art, let any one compare the iron gates of what men call the Police Station at Hyde Park Corner – in the language of the gods, the Triumphal Arch – with the bronze net-work and foliage of Verrochio, which seems to grow and spring like living vegetation round the porphyry sarcophagus of Pietro de' Medici, in the basilica of San Lorenzo, or even with the iron gates of the choir of St. Paul's. Even in the latter, coarser example, there is that boldness and freedom which truly enable us to consider it a work of art, whilst the elaborate and showy park-gates are capital *Brummagem*, and nothing more.

Truly does the old Scottish proverb say 'the *saugh* kens the basket-maker's thumb . Grasped by man, the tool becomes a part of himself; the hammer is pervaded by the vitality of the hand. In the metallic work brought out by the tool, there is an approximation to the variety of nature: slight differences in the size of the flower, in the turn of the leaf, in the expansion of the petal. Here, you have the deep shadows produced by undercutting; there, the playful spiral of the ductile tendril. But in the work produced by the machinery of the founder, there can be nothing of all this life. What does it give you? Correct, stiff patterns, all on the surface: – an appearance of variety, which, when you analyse it, you find has resulted only from the permutations and combinations of the moulds. Examine any one section or compartment, or moulding, or scroll, and you may be certain that you will find a repetition of the same section or compartment, or moulding, or scroll, somewhere else. The design is made up over and over again of tales already twice-told. The most unpleasant idea you can convey respecting any set of men is to say that they seem all cast in a mould; and whatever is reproduced in form or colour by mechanical means, is *moulded* – in short, is perpetually branded by mediocrity; sometimes tame, sometimes ambitious, but always mediocrity. Nor must it be supposed that the effect of Brummagem[1] art does not extend beyond the Brummagem article. In art, in literature, as in morals – in short, in all things – the tone is taken from those which you live amongst and which you copy, whether you will or no: and the same stiffness and want of life which is the result of mechanographic or mechano-plastic means, in paper, silk, cotton, clay, or metal, is caught more or less in every branch of art. All ornamentation, outline, design, form or figure produced by machinery, whether the medium be block, mould, type, or die, may be compared to music ground by a barrel-organ: – good tones, time well observed, not a false note or a blunder, but a total absence of the qualities without which harmony palls upon the ear. You never hear the soul of the performer, the expression and feeling, speaking in the melody. – Even in that branch which is considered by many as art itself, *engraving*, the best judges all declare that, so far from benefiting art, the harm it has done has been incalculable, substituting a general system of plagiarism in place of invention; and if such was the opinion of Lanzi and Cicognara, who only knew the processes of wood and copper engraving, what will not be the result of the means of multiplying the metallic basis, and fixing the fleeting sunbeam, which are now opening upon us by means of chemical science? – Steam-engine and furnace, the steel plate, the roller, the press, the Daguerreotype, the Voltaic battery,[2] and the lens, are the antagonist principles of art; and so long as they are permitted to rule, so long

1 'Brummagem' was a derogatory reference to the cheap and inferior goods manufactured in Birmingham.

2 See section on the electrotype, para. 43.

111

must art be prevented from ever taking root again in the affections of mankind. It may continue to afford enjoyment to those who are severed in spirit from the multitude: but the masses will be quite easy without it. Misled by the vain and idle confidence which we place in human intellect and human faculties, we strive with child-like ignorance, though not with childlike simplicity, to unite the qualities of different, even discordant stages of society. We wish to possess the native energy of a simple state, and the luxury of the highest grade of civilisation; but we strive in vain; the assigned bounds cannot be overpassed. We must be content with the good we have: and, whilst we triumph in the 'results of machinery', we must not repine if one of these results be the paralysis of the imaginative faculties of the human mind.

Lewis Foreman Day: 'Machine-made Art' from *The Art Journal* (1885):

There are two opinions upon the subject of machine-made Art. The more modern, that is to say, the more scientific, school of thinkers, are disposed to look upon machinery as the key to every-thing that is hopeful in the future. Artists, on the other hand, are apt to complain that it is a veritable Juggernaut, under whose wheels the arts must eventually be crushed out of existence.

To reconcile these adverse schools of thought is perhaps impossible: both have such sufficient grounds for the faith that is in them. But there is a standpoint between the two, in the belief, namely, that it is the abuse of the mechanical which has made artists sceptical, and more than sceptical, as to its use in Art.

There is some truth in the uncompromising assertion of artists, that the machine has done nothing for them, that there is no room in the world for any such hybrid thing as machine-made Art; but, like many another uncompromising assertion, it goes beyond the truth. That the great mass of existing manufactured ornament is absolutely intolerable need not be denied. But it is not all bad, any more than it can be said that all hand-work is good. Still less is there any inherent reason why a work of Art, because it owes something to machinery, should be false in taste or unsatisfactory in effect. . . .

The ease with which considerable enrichment, such as it is, can be mechanically produced, and the cheapness of it, taken in con-nection with the fact of the actual artistic superiority of hand-work, has led to the association of mechanical production with cheapness, and to a corresponding nastiness. The cheapness, too, of machine work has led to its abuse. So long as ornament represented actual labour, that was the surest guarantee of some moderation in its use. Machinery opens the flood-gates of extravagance, and we are deluged with cheap abominations. The deepest wrong that mach-inery has done to Art, is in that it has made ornament (or what is meant for ornament) so easy to get that uncultivated persons will not be restrained from using it; and the great majority, even of the so-called cultivated classes, happen to be uncultivated in Art.

The human appetite is at all times quite keen enough for ornament of any kind, but the surfeit of coarse food provided by the machine inevitably sickens all who have any artistic stomach. The need is for less ornament instead of more, greater simplicity in what we do indulge in, and greater discrimination as to where we use it. The tendency of machinery is dead against this much-to-be-desired reform. So far, then, the machine is opposed to Art, and Art to it. . . .

A wiser application of the machine to the purposes of the lesser arts might enable us to dispense with the intermediate 'hand' who

nullifies in execution whatever of Art there may have been in the drawing. As decorative art now stands, and seems likely to stand, the interpretation of the artist's design must be left to one of lower grade. Who that has suffered from such interpretation would not rather trust to the accuracy of the machine than to the inaccuracy of the human hand? Wherever the artist's work is not autographic, he has in some measure to brutalise his design in order that the mechanic who executes it may not brutalise it still more. He must, that is to say, deliberately make his lines harder than need would be, were it not that the interpreter would otherwise be likely to go hopelessly astray, and harden them in a manner very far removed from what he himself would have done. In adapting his design to mechanical reproduction he would doubtless have to be somewhat mechanical in his execution, but not more so than would be necessary if he wished to insure anything like accurate reproduction by the hand of another. And he would have this certainty, that, if his design were only fit, the machine would do its work with un-erring accuracy. Such submission to mechanical needs may be a kind of self-murder, but one might well prefer to commit this sort of suicide at once rather than allow one's self to be tortured to death by even the best-intentioned burglar. . . .

In speaking of machinery we must not leave out of account its effect upon the workman, and so, through him, again upon the work he does. It is quite true, as Mr. Ruskin has pointed out, that the work which gave no pleasure to the workman in the doing, is not likely to afford us much pleasure either. And it would seem, therefore, as if mechanical work must be altogether devoid of interest, alike to him who contemplates and to him who executes it. But this is not quite so: men of artistic temperament assume too readily that work ceases to be interesting in proportion as it is mechanical. Were they to inquire more curiously into their own feelings, they would find probably that they themselves had more enjoyment than they thought in work of a merely mechanical kind. Indeed, the alternation of mechanical with more artistic work is essential to the well-being of the artist. The one kind of work is a relief from the other. He can no more be perpetually working his brains, or pumping his emotions, than he can keep up perpetual motion with his limbs. . . .

It may not be easy for us fully to understand or enter into the feelings of the artisan who is happiest when he has before him the repetition of a simple form over and over again, who rejoices when it mounts to dozens of times, and is overjoyed when it reaches hundreds. Yet the prospect which nauseates us is actually soothing to him. This class of workman does exist, and exists largely. His kind are more in number than the artists. We overlook this when we talk of mechanical art as degrading to the workman. The world was not made for artists only, and the artisan would, as often as not, prefer to work on at the mechanical craft for which he is fitted, rather than be spurred on to efforts as much out of his reach as they are beyond his ambition. . . .

The great use of machinery is of course for the purpose of repetition. The question then occurs, to what extent is repetition desirable? Mere cheapness is not the inestimable boon it is assumed to be. It is a good thing that comfort and a measure of refinement in common things should be brought within the reach of the many – and the more into whose reach they are brought the better; but the cheapness of things does not add to the comfort, and certainly not to the refinement, of those who are placed above want. How much more comfortable, how infinitely more refined, some of our drawing-rooms would be if ornament and ornaments were only dear enough to be more scarce! . . .

If Art cannot be reproduced by machinery, then let us have nothing to do with the machine. But it has been abundantly proved that works of Art may be woven, printed, cast, and otherwise mechanically reproduced. The *further* possibilities of the machine in the direction of Art remain to be tested. So far as it is concerned machinery has never been fairly tried. Machines are resorted to in order to save expense, and accordingly the consideration of cost determines everything in connection with them. One cannot compare work done under such conditions with the spontaneous work of an artist, done without a thought of whether it will pay or not, or with a far-seeing faith in the ultimate success of the best, and only the best. Compare machine-work with hand-work starved down to a price, and the odds are not all in favour of the hand-worker. The manufacturer's real chance of success lies in showing not only what the machine can do, but what it can do best, better than the craftsman who would compete with it. If capable capitalists were to be found, with sufficient knowledge alike of mechanics and of Art, and belief enough in the machine to back it at all risks, then and then only would there be a chance of seeing what it can do, and of estimating the value of machinery as applied to the production of works of Art. The practical and pecuniary value of machinery is obvious. The assertion that it can have no artistic value remains to be proved.

DISCUSSION

A WORD ON SOURCES (UNITS 33 AND 34, ART AND INDUSTRY)

For the purpose of this Foundation Course, YOU DON'T NEED TO PURSUE THE MATERIAL FURTHER. The sources given in the text are both to acknowledge them and to provide them for those who for particular reasons may want to follow them up – and have the time to do so – and especially for *future* reference.

Some of the best sources given, many of them primary sources, are difficult, though not impossible, to get hold of. An excellent place to consult books, periodicals and illustrations on design is the library of the Victoria and Albert Museum. The Museum is itself one of the positive results of the financial success of the Great Exhibition. It is a valuable repository for objects of nineteenth-century design, though these are not always on view and special application must be made to see them.

The Science Museum in London contains several drawing implements of the kind mentioned here in the text. There, also, are the entire contents of James Watt's garret workshop, including his carving machines.

The best place to see early works of graphic art is in the Prints and Drawings Room of the British Museum. For early illustrated periodicals, such as those mentioned here, the Victoria and Albert Museum library is the most convenient source.

ACKNOWLEDGEMENTS

Grateful acknowledgement is made to the following sources for illustrations used in these units:

Tim Benton, Figs. 12, 14, 16; Crown copyright, Science Museum, London, Figs. 87, 88; The Detroit Institute of Art, Plate I; George Eastman House (*Image*), Rochester, N.Y., Figs. 81, 83, 84; I.B.M., Fig. 79; Edward Leigh, Oxford, and M.I.T., Lincoln Laboratory, Figs. 77, 78; Eric de Maré, Figs. 4, 7, 9, 11, 13; Photo Science Museum, London, Figs. 2, 5, 15, 99; Radio Times Hulton Picture Library, Fig. 3; Routledge and Kegan Paul and William M. Ivins Jn., *Prints and Visual Communication*, Figs. 96, 97; The Royal Institute of British Architects, Plates III–VII, and Figs. 1, 6, 8, 10; The Tate Gallery, London, Plate II; The Victoria and Albert Museum, Figs. 41, 42, 45, 59, 60, 61, 73, 107, 108.

All other illustrations in the collection of the author.

Notes

Notes

Notes

FOUNDATION COURSE UNITS

Plate I Whistler. *Nocturne in Black and Gold: the Falling Rocket*. Painted on wood, *c.* 1874. Size $18\frac{3}{8} \times 23\frac{3}{4}$ inches. This is one of the paintings discussed in the Whistler-Ruskin trial. N.B. radio programme, Unit 34.

Plate II Whistler. Nocturne in Blue and Gold: Old Battersea Bridge. *Oil on canvas, c. 1872–5. Size* 19¾ × 26¼ *inches.* (*This was originally called* Nocturne in Blue and Silver No. 5.) *It is another painting which came under attack in the Whistler-Ruskin trial.*

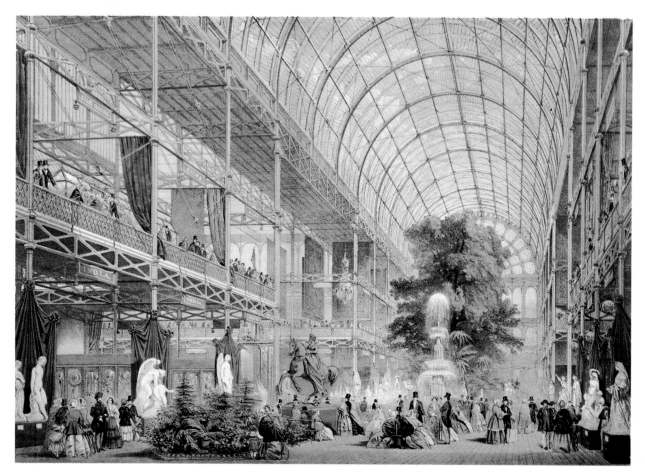

Plate III Lithograph in colour from A. Dickinson's Comprehensive Pictures of the Great Exhibition of 1851 (*1854*). *View of transept.*

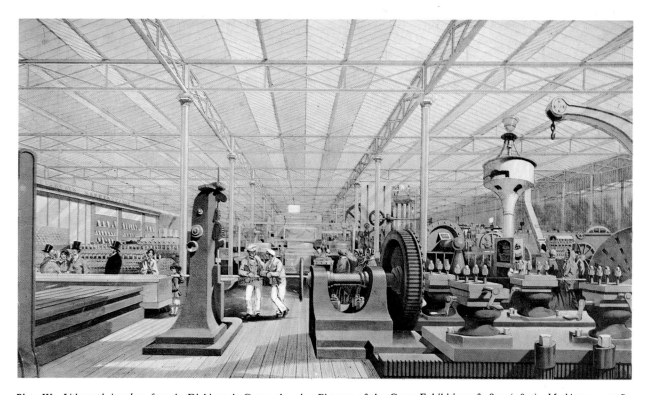

Plate IV Lithograph in colour from A. Dickinson's Comprehensive Pictures of the Great Exhibition of 1851 (*1854*). *Machinery court. See para. 99 in correspondence text.*

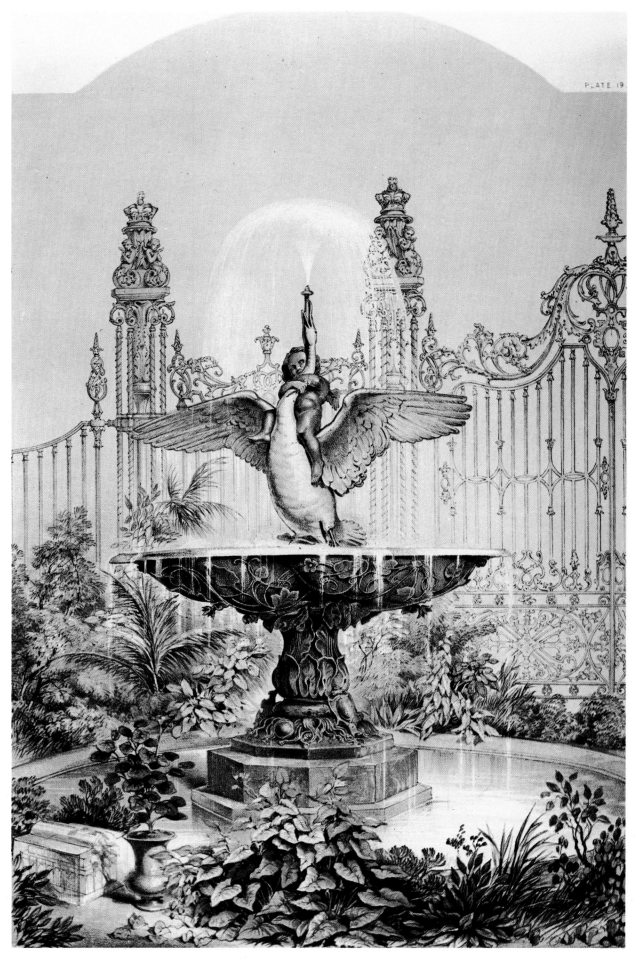

PLATE 19

Plate V Fountain and ornamental gates cast by the Coalbrookdale Co. and exhibited in the Great Exhibition 1851. This illustration from M. D. Wyatt's Industrial Arts of the Nineteenth Century *reveals how critics saw these 'naturalistic' designs merging with live vegetation. You will see more of the gates in the TV programme for this week.*

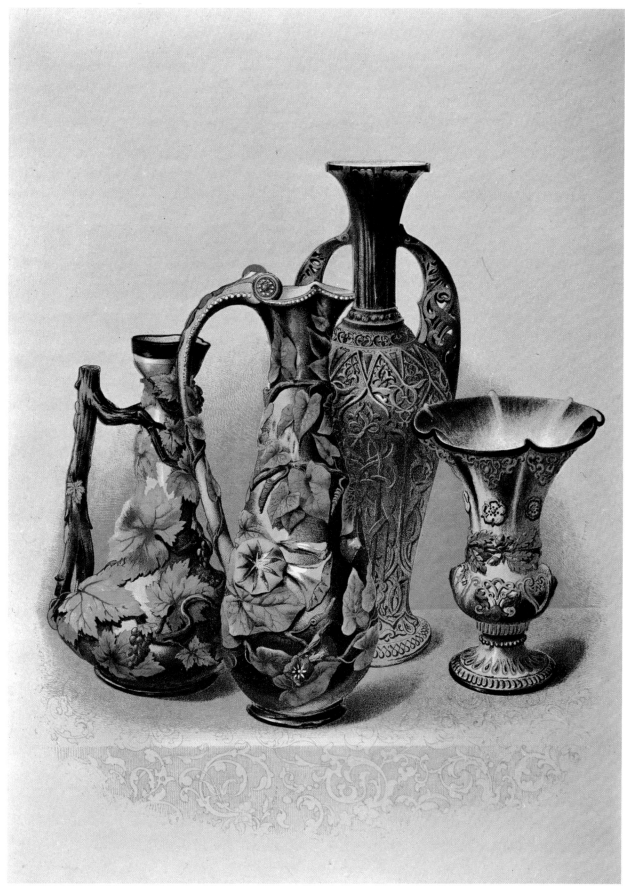

Plate VI A group of earthernware vases by Mansard of Voisinlieu. From M. D. Wyatt, The Industrial Arts of the Nineteenth Century at the Great Exhibition 1851 *(1851–3). Wyatt writes: 'Whether such a revival [of Palissy-type realism] quite coincides with our ideas of the utilitarian application of plates and dishes, is a question upon which, considering the apparent popularity of these items, it might be ungracious to enter further'.*

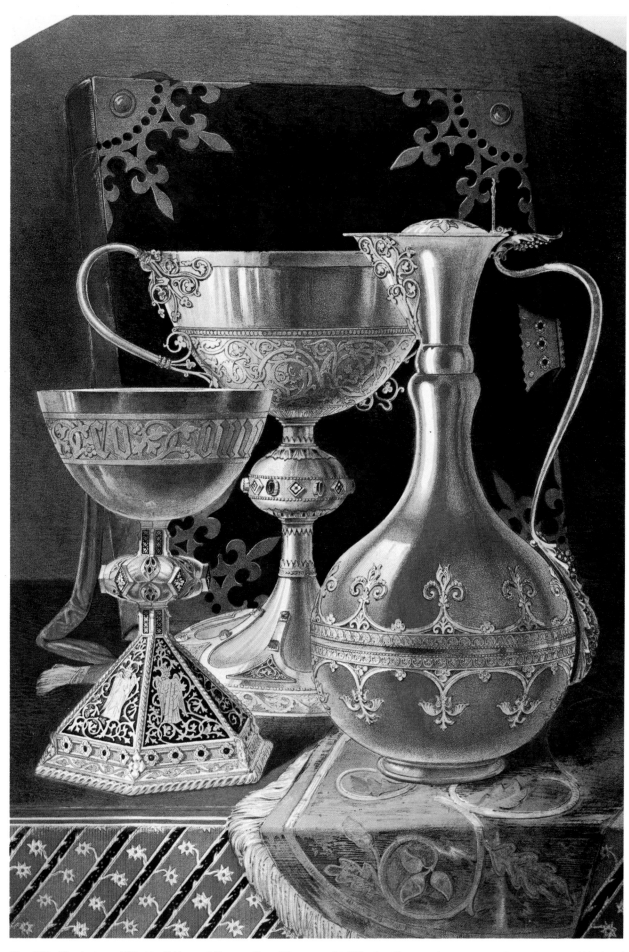

Plate VII Church plate exhibited by Skidmore of Coventry. From Wyatt, op. cit. This plate illustrates the contrasts in colour and texture which pleased the Victorians so much.

The following reproductions of four textile designs are from actual
samples pasted into issues of the *Journal of Design*. They are the same
size as the originals. Though it would be impractical here to cover
the many types of textiles produced at the time, these four give
some indication of one range, from a delicate, flat, floral pattern,
to a bolder and more naturalistic one. One of the purposes in
selecting these is to show how close to our own standards some
Victorian design was. The first two were liked for their graceful
and clean-cut look, and for what was called 'levelness' (i.e. the
ability of the lines and shapes to assume, at a distance, a uniform
flatness). This quality of surface, especially in dress fabrics, was
considered to be of the first importance, especially as the folds
themselves would naturally provide an unevenness of surface. The
third pattern, despite the modelling by shadows in its delicate
forms, was thought tasteful in composition, colour, and successful in
evoking the character of gaiety. The Hargreaves print was praised
as a *tour de force*, and for its brilliancy and purity of colour, the reds
and lilacs especially, on a black ground. The same design was
printed on many other cloths to make it available to all according
to the size of the purse.

Plate VIII Owen Jones. Chintz covering, 1851. *Plate IX Calico dress fabric printed by Salis Schwabe & Co., 1850.*

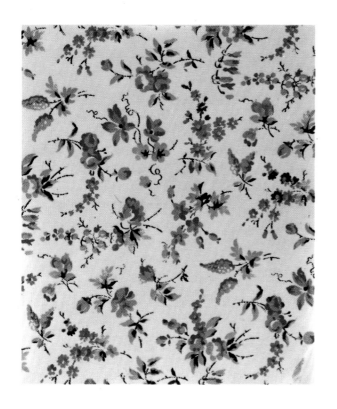

Plate X Calico printed by the Strines Printing Co., Manchester 1850.

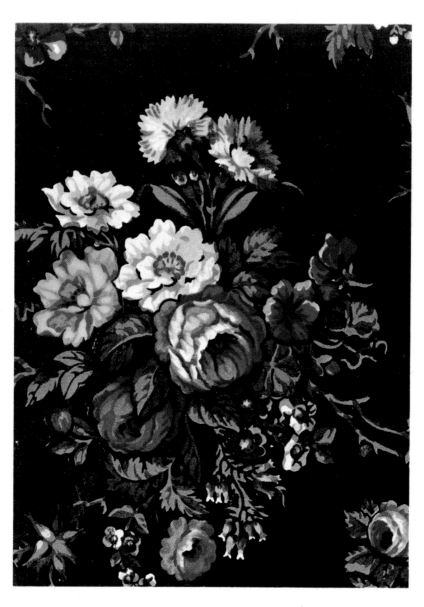

Plate XI Satin cotton printed in nineteen blocks of colour by John Hargreaves, for Liddiards, 1851. Shown in the Great Exhibition.